KEY

🔱 Underground

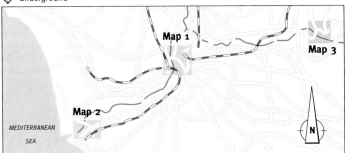

First North American Edition

ISBN 0-8212-2231-7

Library of Congress Catalog Card Number
95-76699

Bulfinch Press is an imprint and trademark
of Little, Brown and Company (Inc.)
Published simultaneously in Canada by
Little, Brown & Company (Canada) Limited

PRINTED IN SPAIN

ROME

Sarah Carr-Gomm

A Bulfinch Press Book
Little, Brown and Company
Boston • New York • Toronto • London

CONTENTS

782528

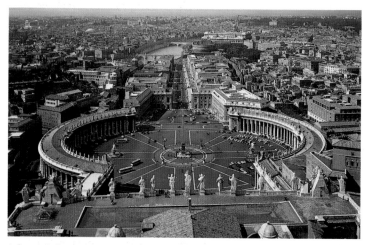

1. BERNINI'S PIAZZA FROM THE ROOF OF ST PETER'S

Rome is a bustling capital city with a history spanning over two thousand years. There is the Classical Rome of the Forum, Colosseum and Pantheon; the Rome of the early Christian Church; the Rome of the wealthy Renaissance Papacy; and the city of Baroque palaces and churches. Great monuments survive from each period but there are also sophisticated shopping streets, open-air markets, great fountained piazzas and narrow alleyways in the medieval quarters. As Henry James's brother William found, the Eternal City is 'a feast for the eye from the moment you leave your hotel door to the moment you return.'

Rome's history has been characterized by brutal power struggles. From the Fall of the Empire in AD 410 until World War Two, the city has been repeatedly attacked, ransacked and occupied by foreign forces. From Charlemagne to Napoleon and Mussolini, megalomaniacs have tried to revive her Imperial status but in spite of devastations over the centuries no-one has ever managed to obliterate Rome's past.

According to legend, Rome was founded in 753 BC when Romulus traced out the city walls on the Palatine. The twins Romulus and Remus had been abandoned as infants on the banks of the Tiber because their mother, Rhea Silvia, descendant of Aeneas the hero of Troy, had been raped by Mars. A she-wolf suckled them and they were brought up by shepherds; but the sons of the god of war quarrelled, Romulus killed his brother and gave his name to the new city. Lacking women in the settlement, he invited the Sabines to attend a festival, the women were raped, then agreed to become their captors' wives and persuaded their dishonoured fathers and brothers to unite with Rome. Neighbouring tribes were defeated as six more Kings of Rome followed Romulus, the Temple of Jupiter was built on the Capitol, the Forum was developed in the valley below and the city, favourably positioned near the coast, expanded over the hills

surrounding the Palatine and Capitoline: the Esquiline, Aventine, Caelian, Viminal and Quirinal.

The Republican era was established in around 510 BC. Consuls were nominated to the Senate and tables of law were set out. Religious officers were appointed, ruled over by the High Priest, the Pontifex Maximus, and great importance was placed on divination and augury. Temples were built to Apollo, the god of the sun; to Mercury, the god of trade; and to Ceres and Saturn, the gods of crops; and sacrifices were made to placate them. In the fourth century the Gauls invaded but the geese, sacred to Juno, alerted the guards of the Capitol and Rome continued to prosper. Legions carried the device still found in the city today, S.P.Q.R. (Senatus Populusque Romanus – The Senate and People of Rome) as they marched in conquest, and by 270 BC they were masters of the whole peninsular south of the River Po. Rome's desire for expansion sent legions out in all directions of the compass and her conquests can be seen in a series of modern maps on a wall in the Via dei Fori Imperiali near the Colosseum.

Generals, rich with the spoils of war, could buy loyalty from their soldiers and then take political control. Thus Julius Caesar chased Pompey to Egypt, where he met Queen Cleopatra. They became lovers and she bore his son and on his return to Rome, he installed them both in a house at the foot of the Aventine. Caesar enlarged and completed the Forum (page 29) where to celebrate his military successes he held a banquet in 45 BC for 22,000 guests. Unable to convince his opponents that he was loyal to the Republic, his obvious ambition brought his downfall on the 15 March 44 BC, when he was stabbed to death by Brutus and his collaborators on the steps of Pompey's theatre, near the Campo dei Fiori. Caesar had named his adopted son, Gaius Octavius, as his direct heir and Octavian assumed the title Augustus and became Emperor in 27 BC, thus ending the Republican era. His popularity came through the restoration of peace and his extensive building projects which, it is said, turned a city of brick into one of marble.

Tiberius followed his father and built the first of the lavish Imperial palaces on the Palatine, then retired to the Island of Capri. His successor, Caligula, was so unpopular that he was murdered by his own body guards and the more amiable Claudius was poisoned, probably by his wife. These Emperors were eccentric, cruel and debauched but Nero surpassed them all. He was sixteen when he became Emperor and 'disgraced himself with every kind of abomination, natural and unnatural, leaving no further depth of debauchery to which he could sink'. Little remains of his vast Palace, known as the Golden House, which he set in a two-hundred-acre park stretching from Palatine to the Esquiline. Hated by all, he woke one night to find the palace deserted; he fled in terror but was found and managed to plunge a dagger into his own throat to avoid being publicly flogged to death.

To maintain popularity, Emperors realized the importance of providing free entertainment and distributing food to a population with very high unemployment. 'Rome may be ruled with bread and circuses' wrote Juvenal. For each working day there was one holiday and by today's standards the entertainments would be considered atrocious. Gladiators were the stars but in the intervals cripples, dwarfs, obese women and animals were matched in combat for the amusement of the audience. When the

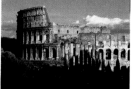

2. THE COLOSSEUM

3. *GLADIATOR MOSAIC* (GALLERIA BORGHESE, ROME)

Colosseum was finished a hundred days of celebrations witnessed the slaughter of numerous gladiators and five thousand wild animals; leopards, lions, tigers, camels, bears, giraffes, ostriches and crocodiles were massacred.

By the second century, the city had reached the height of its splendour. Magnificent buildings on a massive scale were decorated with the richest marbles, sculptures, stucco and gilded bronze. With her stadiums, market-places, public basilicas and enormous thermal baths, Rome

THE CLASSICAL HERITAGE

From the Greeks, the Romans inherited an entire architectural vocabulary. They took over the Doric, Ionic and Corinthian orders; the horizontal entablature consisting of architrave, frieze and cornice; and the triangular pediment. These three elements together make the temple facade, a ubiquitous combination which has been applied to public and domestic buildings as well as churches throughout the centuries. Early Roman buildings, like those of Greece, were meant to be admired from the outside; the interior was essentially a box or series of boxes. A number of later innovations allowed the Romans to create more impressive interior spaces. From the Etruscan vault they developed the revolutionary arch and the dome. Moreover, in the second century BC they invented concrete, a mixture of pozzolana (volcanic ash), lime and sand which creates a material of great strength and durability. The coffering found in so many ceilings is decorative, but it is also thought that the design of panels sunk into the concrete was to lighten the load and to help the cooling process. In AD 64,

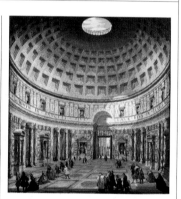

4. G. P. PANNINI *INTERIOR OF THE PANTHEON*, 18TH CENTURY (PRIVATE COLLECTION)

during Nero's reign, a fire totally destroyed seven of the fourteen zones of Rome and severely damaged four more, making space available to utilize these new architectural developments. Imperial ambition produced buildings on an enormous scale, with complex designs and daring technical feats.

Since the Renaissance, the Colosseum with the orders on its piers, the facade and dome of the Pantheon and the temples, basilicas and triumphal arches of the Forum, have inspired architectural designs throughout the world.

appeared to be constructed entirely for pleasure. But this included an extra-ordinary display of cruelty. Even at the theatre there was real not simulated violence, and when required the actor was substituted by a condemned criminal who was tortured to death on stage.

With a population of one million, there was a vast urban poor, the majority of whom lived in *insulae*, blocks of flats some six storeys high, often one family to a room. The skins covering the windows would have made them dark and the braziers and oil lamps were inefficient and dangerous; the poorly constructed buildings often collapsed or caught fire. There was a vast slave population mainly controlled by fear; slaves were often flogged and crucified along Via Appia Antica.

During Nero's reign Peter, 'the Prince of the Apostles' came to Rome and established the first Christian community. Shortly afterwards Paul arrived; both were martyred around AD 64. They were given paupers' graves outside the city walls and as the persecutions increased, catacombs were constructed around them. These labyrinths of corridors with tombs lining the walls were dug under land belonging to converts. Some were four levels deep and covered many kilometres. A few Emperors tolerated the new religion but there were frequent waves of persecution and Christians suffered agonies to provide entertainment in the theatres. But Christianity could not be repressed and the numbers of converts grew larger; they met for worship in private houses known as *tituli*. On 28 October AD 312, the first Christian Emperor Constantine defeated Maxentius at the Milvian Bridge just north of Rome and he entered the city as uncontested ruler of the Empire in the West. His mother, Helena, had been converted and he was convinced that his victory was a reward for his interest in the new faith. In AD 313 Christianity was legalized. However, the majority of aristocrats remained bound to old traditions and to satisfy their expectations Constantine built huge baths on the Quirinal, enlarged the enormous Basilica of Maxentius in the Forum (page 31) and erected his triumphal arch next to the Colosseum (page 19).

Over the graves of Peter and Paul and other early martyrs, Constantine built basilicas for Christian congregations; these were designed to hold between 800 and 1400 people and followed a standard plan like their Roman counterparts, having a nave, aisles and a terminating apse, where an altar replaced a statue of the Emperor. They were usually outside the city walls in order to avoid antagonising the pagan ruling classes. Only the Lateran was just within the city, built on land Constantine had inherited as part of his wife's dowry. Christianity was not compatible with Roman religion and Constantine had never liked the city. By AD 330 he had left

5. RAPHAEL
*THE BATTLE OF
MILVIAN BRIDGE*
(STANZE,
VATICAN)
1520–21 (SALA
DI CONSTANTINO,
VATICAN)

to found Constantinople, now Istanbul, as the new Christian capital in the east, and the Emperors never again took up residence in Rome.

The Empire had been under attack from all sides and was soon in ruins. In 410 the army of Alaric the Visigoth was the first to march through the gates: 'Fallen has the city to which the world once fell' wrote Jerome from the Holy Land. Rome was to suffer greater humiliations. In 453 the advance of Attila the Hun was halted just outside the walls, but in 455 Genseric the Vandal ravaged the city and loaded his ships with captives and plunder. In the following century Rome was occupied by Belisarius, general of the Byzantine forces, and by Totila the Ostragoth. By the end of the sixth century the city had virtually collapsed, its population reduced to a tenth of its former size. Those who could not flee were dying of starvation and disease. But as her political power dwindled, Rome became the spiritual centre of the West.

In 590 a procession of penitents passed Hadrian's mausoleum where the Archangel Michael appeared and indicated that the plague would soon be over (page 26). Leading the procession was Pope Gregory I, later canonized and known as 'the Great'. Pilgrims started to flock to Rome, and to accommodate them pagan buildings, such as the Pantheon, were consecrated (page 58). As well as pilgrims, there were those fleeing Muslim iconoclasts, many of whom were Greek craftsmen, called Cosmati. Their forms of decoration are known as 'Cosmatesque', from which we get the word 'cosmetic'; they used coloured marble chips set into concrete to form geometric patterns, and many examples can still be seen in Rome's medieval churches.

On Christmas day 800 Charlemagne, the Frankish king of much of northern Europe, was crowned Holy Roman Emperor by the Pope in St Peter's. This event marked the beginning of centuries of violent disagreement over the control of papal elections. The Church also claimed to have temporal power inherited from the Emperor outlined in a document known as *The Donation of Constantine*, which later proved to be a forgery. Romans hated the election of a foreign pope. Aristocratic Roman families emerged as protectors of the city and one after another the popes

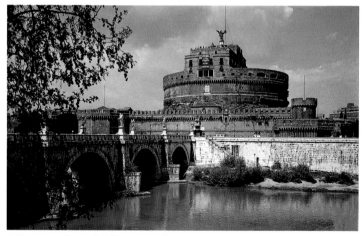

6. VIEW OF THE CASTEL SANT'ANGELO AND BRIDGE

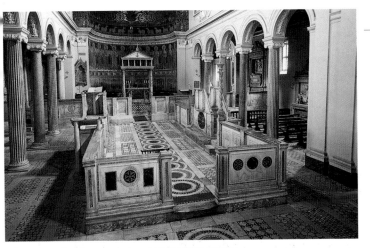

7. INTERIOR OF SAN CLEMENTE SHOWING COSMATESQUE FLOOR

were murdered, deposed or exiled. The papal court overtly rivalled the secular powers of Europe, and the pope and his prelates apparently dined like princes on vessels of gold, slept in the arms of their paramours and drove in luxurious carriages which no king would have scorned to possess.

The division between temporal and spiritual power came to head under Pope Gregory VII. In 1084 the army of the Holy Roman Emperor took Rome, and the troops of Robert, the Norman Duke of Apulia and Calabria, entered the city as liberators but then proceeded to pillage the city for ten days, mercilessly sacking, raping, murdering, and reducing whole areas to rubble. With peace restored, noble families strengthened their mansions, many built into ancient monuments, and forced the Pope to restore the Senate. Churches were rebuilt, the Vatican was fortified and the hospital of Santo Spirito built for poor pilgrims on the Tiber. The popes resumed their opulent lifestyle, ignoring critics who pointed out that Christ and his Apostles were poor. However, they were happy to bless others who devoted their life to poverty: the Franciscan rule was confirmed in 1210 and their church was established at Santa Maria in Aracoeli (page 77), and the Dominican rule was confirmed in 1216, with their headquarters later set up at Santa Maria sopra Minerva (page 84). In 1300 Boniface VIII proclaimed the first Holy Year: donations poured into Rome, pilgrims flocked to the city and threw money at shrines and bought relics and mementoes.

Disagreements continued but when the French came to protect the Pope from the Emperor the consequences were again disastrous. By 1305 the French were able to manipulate the election of Clement V who abandoned Rome in 1309 to set up court at Avignon. Rome was once again left to decay, noble families waged war on one another, and anarchy ruled in the streets. Cola da Rienzo, the short-lived self-styled ruler, the learned Petrarch and Saint Catherine of Siena all begged the Pope to return. The elections of 1378 brought the great Schism. Ignoring the new French Pope in Avignon, Rome elected her own and the solution of deposing both in favour of another resulted in three popes existing at the same time. It was not until 1417 that the papacy returned to Rome with the election of Martin V from the Roman house of Colonna.

The fifteenth-century popes again began to restore the city whose population had been reduced to a mere 17,000. Churches were re-roofed, piles of rubbish were removed and many streets were paved, but rebuilding further destroyed the ruins of ancient Rome as wagonloads of building material were taken to lay new foundations. The Vatican Palace was rebuilt as it was now the seat of the re-established papacy (page 100); and St. Peter's emphasized the papal dynasty as the heirs of Christ's first vicar on earth.

However, the Renaissance popes were scarcely more virtuous than their medieval predecessors. Nepotism was rife: Sixtus IV (reigned 1471–84) made his young relations cardinals or gave them equally lucrative posts. Alexander VI (reigned 1492–1503), the Borgia Pope, had numerous mistresses and at least six illegitimate sons and a daughter, Lucrezia, with whom he is said to have slept.

In 1503 Julius II was elected. His determination to assert the temporal power of the church and drive the foreigners from Italy was illustrated by the very name he chose for his pontificate. He took control of the Papal States and formed a professional army, the Swiss Guards, who with their striped hose, doublets and halberds, are now the domestic bodyguard of the Vatican. In Rome he began projects which he intended should surpass the grandeur of antiquity. With Bramante, he extended the Vatican and pulled down old St. Peters to begin the building again on an enormous scale (page 88). Raphael frescoed his private apartments (pages 116 and 117) and Michelangelo was to carve his monumental tomb (page 92) and decorate the Sistine Ceiling (pages 112 and 113).

The extravagant building programmes were financed by charges made on papal bulls and dispensations and sales of indulgences, as well as religious and secular posts. Those who attacked the materialistic values of the popes were condemned and usually burnt as heretics. There had long been a cry for church reform, but vociferous critics such as the Florentine monk Savonarola, who called Rome 'the sink of iniquity', were not surprisingly excommunicated. During the papacy of Julius II, Martin Luther came to Rome and was appalled by what he saw. In 1517 he nailed his ninety-

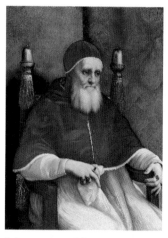

8. Raphael *Julius II* (National Gallery, London)

9. Fresco in the Nymphaeum of The Villa Giulia

It is a constant delight to wander through the streets of Rome, which inevitably lead to one of her numerous squares. Enlivened by cafés and restaurants, they are always full of people, especially in the early evening when Romans take a *passegiata*, or stroll, with friends and relations. The most wonderful squares in Rome are Piazza della Rotonda, Piazza Navona (page 60), Piazza di Spagna (page 62) and Campo dei Fiori. The latter is so called because in medieval times it was a meadow. In the sixteenth century it became a place of execution and in the centre stands a sombre statue of the philosopher, Giordarno Bruno, on the spot where he was burnt in 1600 as a heretic. Since 1869, it has been a market place, and on weekday mornings it is full of colourful stalls selling flowers, fish, fruit and vegetables.

In almost every piazza there is a fountain. Rome has always had a good supply of water, first from natural springs, and then from eleven aqueducts built between 312 BC and AD 226. By the time the Goths

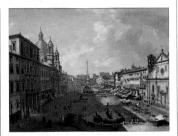

10. G. P. PANNINI *PIAZZA NAVONA*, 18TH CENTURY (MUSÉE DES BEAUX-ARTS, NANTES)

sacked the city in 410, they were feeding 1,212 public fountains, eleven Imperial thermae and 926 public baths. Built for the Baths of Agrippa in 19 BC, the Aqua Vergine still supplies the fountains in the Piazza di Trevi, Piazza del Popolo, Piazza della Rotonda, Piazza di Spagna and others. Renaissance and post-Renaissance Popes restored the fountains, damaged by wars and by time, and Bernini's imagination transformed them from simple geometrical structures into spectacular pieces of theatre. Beside many fountains there is often a tap with water to provide drink and also to wash out the drains.

INTRODUCTION

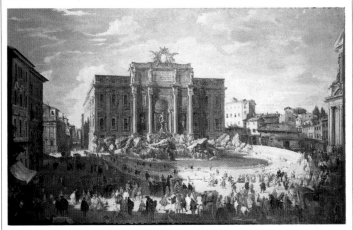

11. G. P. PANNINI *BENEDICT XIV VISITING THE TREVI FOUNTAIN*, 18TH CENTURY (AGNEW & SONS, LONDON)

five theses to the door of Wittenberg church, thereby setting in motion events leading to the Protestant Reformation.

In 1527 German soldiers, most of whom were Lutheran, marched across the Alps and were joined by mercenaries until they were over 20,000 strong. By the time they reached Rome they were desperate and hungry. On 6 May they entered the city and broke into convents, churches, hospitals and palaces and slew whoever they found or threw them into the Tiber. They robbed corpses of their jewels, played football with the heads of Saints Andrew and John, savagely tortured men and violated women. With Pope Clement VII a prisoner in the Castel Sant'Angelo, the army plundered the city for nine months, in the worst sack of many in the history of Rome, destroying thousands of buildings and halving the population. They were only finally driven out by the plague and the stench of rotting bodies.

Rome gradually struggled back. Pope Paul III's concern for church reform and the Counter-Reformation saw the establishment of the Jesuit Order and establishment of the Council of Trent. Successive popes were stricter: nepotism was suppressed, the granting of indulgences and dispensations restricted; the powers of the Inquisition increased; prostitutes were driven out of the city and Catholic missionaries were sent out across the world. The process of reform was often bloody: under Sixtus V, it was said that there were more heads on the Ponte Sant'Angelo than melons in the market. Sixtus V was also ruthless town planner. He restored the water supply and built a new aqueduct, new bridges appeared across the Tiber and the city's narrow streets were widened and redirected in order to link major basilicas. At important crossings and in front of St. Peter's he re-erected obelisks to be seen from afar. The Dioscuri, colossal statues of the twins Castor and Pollux standing by their horses, were found in the Baths of Constantine and placed outside the Palazzo del Quirinal, now the residence of the President of the Republic.

Seventeenth-century town planning was dominated by the giant talents of Bernini, Borromini and Pietro da Cortona, encouraged by extravagant patrons such as Cardinal Scipione Borghese and the Barberini Pope, Urban VIII. When the sculptor was tempted to go to work in France, the Pope said 'Bernini was made for Rome and Rome was made for him' and he was pressed instead to finish the interior decoration of St. Peter's and create its monumental Piazza (pages 89 and 89). But to construct such splendid Baroque structures, the Pope destroyed more of ancient Rome which gave rise to the quip *Quod non fecerunt barbari, Fecerunt Barberini* (What the barbarians did not do, the Barberini did). Over the century,

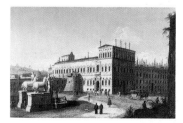

12. FOLLOWER OF CANALETTO *PALAZZO DEL QUIRINAL*, 18TH CENTURY (PRIVATE COLLECTION)

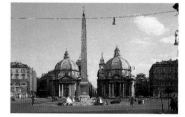

13. VIEW OF THE PIAZZA DEL POPOLO, ROME, DESIGNED IN THE 18TH CENTURY

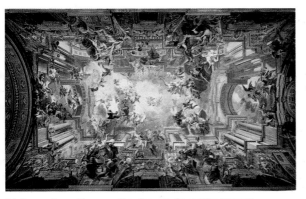

14. ANDREA POZZO *CEILING OF SANT'IGNAZIO, ROME*, 17TH CENTURY

medieval fortresses gave way to noble palaces with extensive gardens and piazzas with sparkling fountains; the vertical towers and campanile on the skyline were outnumbered by round cupolas and domes. By the eighteenth century these sites were attracting many visitors to Rome, most notably the English *milordi* on their Grand Tours, from whom it was apparently easy to extract money.

Much has changed since the days of the Grand Tour. The animals which once grazed in the Forum and pulled barges up the river have been cleared away, and the ivy covering the ruins has been removed. The Tiber has been embanked halting frequent floods and in 1860 the Pope blessed the first train to leave Rome at a speed of thirty miles per hour. In 1870 Rome became the capital of the newly unified Italy, and her King Victor Emmanuel II established his court at the Quirinal. In 1929 the Lateran Pact made the Vatican an independent sovereign state. At the end of the nineteenth century gardens and parks were swallowed up to build apartment blocks, hotels, offices, embassies and consulates, the Palace of Justice, Ministries of War and Finance, hospitals and the Monument to Victor Emmanuel (page 118). To accommodate the invasion of traffic, wide roads were constructed over ancient sites, allowing for race-track driving. Today, traffic is restricted and many areas have been cordoned off; cars no longer spoil the picturesque quarters and glorious piazzas. The churches, palaces and monuments of Rome are a wonder for modern tourists who must, like the Grand Tourists, be wary of how they part with their money.

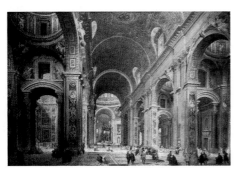

15. G. P. PANNINI *INTERIOR OF ST. PETER'S, ROME*, 18TH CENTURY (PRIVATE COLLECTION)

THE GRAND TOUR

In the eighteenth century, the Grand Tour was part of the education of a wealthy young English gentleman. Having read the history, philosophy and politics of the ancients at school or university, he set off to continue his studies abroad, accompanied by a tutor. Some were distinguished scholars, while others had little control and were as new to the sites as their charges. As well as sightseeing, there were lessons in fencing, dancing, riding, music and drawing and a round of social engagements. There were operas to see, cameos, medals, paintings and prints to buy and portraits to pose for. Pompeo Batoni (1708–87) painted 150 portraits of Englishmen set against Classical props from his studio. Pannini (1691–1765) and Hubert Robert (1733–1808) painted the ruins, and Piranesi (1720–78) drew or etched them. Numerous copyists would reproduce an Old Master on request. These works often formed the basis of private collections of the aristocracy, whose enthusiasm spread the taste for Italian art. Between 1710 and 1740, 148 country houses were built in the Palladian style in Great Britain by those who had taken a Grand Tour.

Guide books recommended bringing an enormous amount of paraphernalia including dividers for measuring buildings, an inflatable bath with bellows, a tinder box for lighting fires, endless remedies for diseases and lice-free linen. Most Grand Tourists took at least one servant with them but the richest would travel with many. As well as an artist to record the sites, William Beckford took his physician and a harpsichordist, and Lord Burlington took his accountant, three gentlemen of the household, a postilian, a groom, a valet, three footmen and all his dogs. He returned with 878 packing crates of loot.

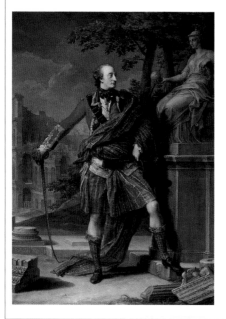

16. POMPEO BATONI *GENERAL, THE HON. JOHN WILLIAM GORDON OF FYVIE*, 1766 (FYVIE CASTLE, NATIONAL TRUST OF SCOTLAND)

ART

IN

FOCUS

Museums

Paintings

Applied Arts

Architecture

Consecrated 13 BC

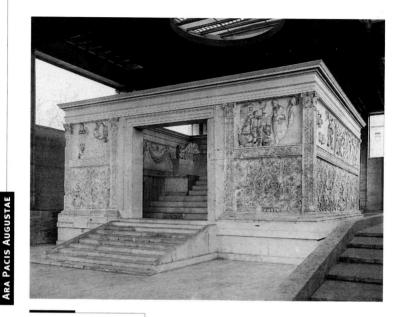

Address
Via di Ripetta/Lungotevere
in Augusta
Roma
℗ 67.10.30.69

Map reference
①

How to get there
To Lungotevere in Augusta:
buses 81, 90, 90b, 926

Opening times
Tue to Sun 9–1. Closed
Mon.

Entrance fee
L. 3,750

The Ara Pacis Augustae was an altar dedicated to peace, established in the Empire by Augustus and consecrated on 4 July 13 BC. The altar itself is surrounded by a beautifully carved screen; the lower part has plants, birds, butterflies, lizards and other reptiles, while on the front and back are scenes of the origins of Rome. The reliefs on the sides show the procession which took place when the altar was consecrated: Augustus is followed by Tiberius and other members of his family; the children are Germanicus and the future Emperor Claudius. Some fragments of the frieze were found in the sixteenth century in the Campus Martius but attempts to find more failed until 1937 when archaeologists were able to first underpin the palace above the dig and then freeze the water which had previously flooded the excavations at its source. It was carefully reconstructed and is now housed in a rather incongruous building. Nearby is the enormous mausoleum of Augustus, built in 28 BC, where Augustus, Tiberius, Caligula, Claudius, Livia and other members of the Imperial family were all buried.

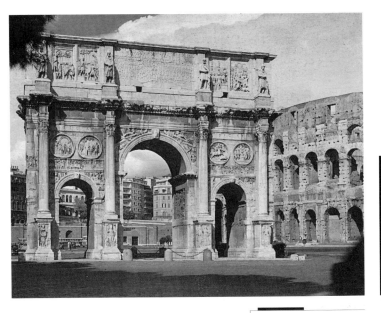

The Arch of Constantine commemorates Constantine's victory over Maxentius in AD 312. This was essentially a triumph for Christianity, but the Emperor was politically cautious and the decoration remained pagan in order to satisfy the reactionary Senate and upper classes. The reliefs and roundels above the smaller arches and two lower ones on the ends show Constantine speaking to the people, and his triumphs and captives. These were the only carvings done specifically for the arch and they are of inferior quality to the rest, which were taken from earlier monuments. The reliefs of victorious battle scenes high up on the ends and inside the central archway were probably taken from an arch dedicated to Trajan. The eight rectangular reliefs on both sides of the attic show scenes from the life of Marcus Aurelius and eight roundels on the main facades represent scenes of hunting and sacrifices to the gods, and come from Hadrian's reign. Roman triumphal arches have provided inspiration for similar designs all over the world.

Address
Via di San Gregorio, Roma

Map reference
②

How to get there
To the Colosseum: Metro B. Buses 11. 15, 27, 81, 85, 87, 118, 186, 204, 673

Built AD 206–217

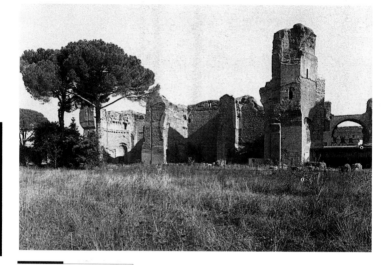

Address
Via delle Terme di Caracalla,
Roma
✆ 575.86.26

Map reference
③

How to get there
To Piazzale Numa
Pompillio: buses 90, 90b,
118, 160, 613, 671, 714, 715

Opening times
Winter daily 9–4/4.30.
Summer Tue to Sun 9–7,
Sun and Mon and public
holidays 9–12

Entrance fee
L 8,000

These great Baths were begun by Septimius Severus and finished by his son, Caracalla. They were the largest in Rome at the time, with accommodation for 1,600 people, and they were still in use in the sixth century. Going to the baths was a long affair; a Roman might start by exercising, he would then have a good sweat in small dry hot rooms, then a rest in the *calidarium*, a damp type of Turkish bath, where he would be scraped by slaves before he began to cool off in tepid rooms before taking a plunge in the cold pool. Finally, he would be rubbed down with scented towels. Underneath the baths was the vast service area, with stoking rooms, furnaces and store-rooms and surrounding them were gardens, a stadium, libraries and shops. The baths were lavishly decorated with mosaics, marble and sculptures, and although these have disappeared the brick baked ruins have grandeur and beauty. Here Shelley composed a large part of his *Prometheus Unbound* and each summer, in the ruined apse which was originally part of the circular calidarium, operas are performed, with massive casts and horse-drawn chariots.

Built 298–306, converted 1560s

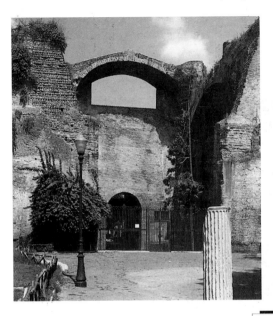

The Baths of Diocletian were originally enormous. In the sixteenth century a Carthusian monastery was built into the ruins of the baths and a pious priest had a vision of angels amongst its vaults. In 1561 Pius IV consecrated the church of Santa Maria degli Angeli, constructed out of the huge *frigidarium* and central hall. Michelangelo (1475–1564) used the longitudinal space as the nave, but in 1749 the monks asked Vanvitelli (1700–73) to transform the church; the axis was then swung round to its present position, using the ruins of the *calidarium* or hot room, and creating an entrance hall which was part of the former *tepidarium*. In the eighteenth century the walls were also covered with late Baroque decoration. Even though Michelangelo raised the floor level some six feet for fear of damp, the original scale of Diocletian's baths is apparent. A large part of the rest of the ruins have been renovated to house the collections of the Museo Nazionale Romano or Museo delle Terme (page 48).

Address
Piazza della Republica, Via Cernaia 9, Roma

Map reference
(4)

How to get there
To Piazza della Republica: Metro A. Buses 57, 64, 65, 75, 170, 492, 910

Opening times
Daily 7–12.30 and 4–6.30

Begun 1537

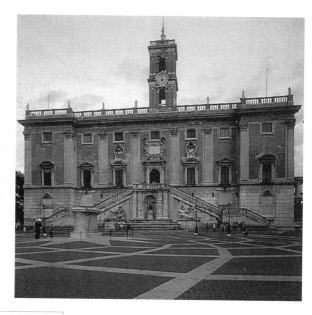

Address

Piazza di Campidoglio, Roma

Map reference

⑤

How to get there

To the Piazza Venezia, buses 44, 46, 56, 57, 60, 62, 64, 65, 70, 75, 81, 85, 87, 90, 90b, 95, 160, 170, 181, 186, 204, 492, 710, 716, 718, 719

The easiest access to the Campidoglio, or Capitoline, is up the shallow ramp guarded by two Egyptian lions with huge late Roman statues of Castor and Pollux at the top. The Capitoline is the most important of the seven hills of Rome; the great Temple of Jupiter once stood here overlooking the Forum in the valley below. On its slope was the ancient *Tabularium*, or state archives, and out of this grew a medieval fortress where in the twelfth century the Senate of Rome was established. By the sixteenth century the buildings on the Capitol were in a dilapidated state and in 1537 Michelangelo (1475–1564) was commissioned to redesign the piazza as a worthy civic centre for Rome. He designed two identical facades facing one another, their awkward angle harmonized by the oval pattern of the pavement, and gave the Senate House a grand double staircase leading up to the raised central door. The Campidoglio now faces modern Rome with its back to the Forum. Dignitaries are still welcomed here, and the Palazzo dei Conservatori is the registry office where civic marriages take place.

The Capitoline Museums are housed in two buildings with identical facades designed by Michelangelo (1475–1564) facing one another across the Piaaza; the artist imaginatively set the loggias of the Capitoline and Conservatori Palaces behind the main facade and united their floors with giant pilasters. There are also inventive window designs, especially in the centre.

Some of the exhibits formed the oldest public collection in the world when Sixtus IV gave them to the people of Rome in 1471; the collection has been added to ever since. Looking from the flight of stairs into the piazza, the Capitoline Palace is on the left; in the courtyard is a statue of a reclining river god from the second century AD known as *Marforio*. It was one of Rome's 'talking statues' and is a pair to *Pasquino* standing in the piazza of that name off the Piazza Navona. It was a tradition for Romans to put a witty remark on a topical subject on their pedestals. Among the more important pieces in the Classical sculpture collection are the recently restored equestrian monument of *Marcus Aurelius*; the *Capitoline Venus*; the marble *Faun*; the *Dying Gaul*, the *Greek Boy with a Thorn* and the *Capitoline She-Wolf*. There is also a series of wonderful portrait busts bringing alive Rome's rulers from the anonymous to the most famous: among the busts of Emperors are Augustus in old age, the vicious Caracalla and Septimius Severus. In the courtyard of the Palazzo dei Conservatori on the opposite side of the square are pieces from the great statue of Constantine and several fragments. Inside, the Palace houses some Greek sculpture, a picture gallery and collections of coins and porcelain. There are wonderful views from the windows.

Address
Palazzo dei Conservatori and Palazzo Capitolino, Piazza del Campidoglio, Roma
℡ 67.10.20.71

Map reference
ⓖ

How to get there
To the Piazza Venezia, buses 44, 46, 56, 57, 60, 62, 64, 65, 70, 75, 81, 85, 87, 90, 90b, 95, 160, 170, 181, 186, 204, 492, 710, 716, 718, 719

Opening times
Tue to Sat 9–1.30, also Tue 5–8; Sat 8.30–11 in summer and 5–8 in winter. Sun 9–1. Shut Mon.

Entrance fee
L 10,000

THE CAPITOLINE MUSEUM

Marcus Aurelius

AD 161–80

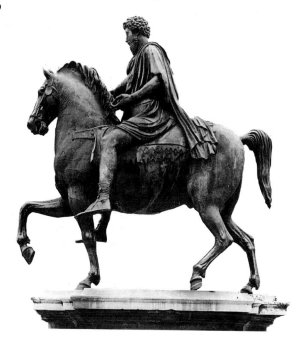

The gilded bronze equestrian statue of Marcus Aurelius has recently been cleaned and is now preserved behind glass. It is the only equestrian bronze to survive from ancient Rome because it was erroneously thought to be of Constantine, the first Christian Emperor, and this saved it from the fate of so many others which were smashed or melted down for their materials. Throughout the Middle Ages it stood outside the Lateran Basilica and was brought to the Campidoglio in 1538. Michelangelo designed the small oval base for it in the centre of the piazza, which now sadly stands without its horse and rider.

This noble statue was executed during the Emperor's reign and is a staggering technical feat. Perfectly balanced on only three hooves, the horse walks forward, with pricked ears, flared nostrils, and mouth pulled open by the bit as his rider sits upon him bare-back. The image of the Emperor with his arm outstretched is a commanding one, created at a time when the Empire was threatened by invasion on all its major frontiers; his column depicting scenes from the northern wars stands in the Piazza Colonna on the Corso. This highly educated, philosopher-emperor left his *Meditations* which reveal his intense religious and moral feelings. This statue was to inspire Donatello in the fifteenth century and subsequently the many post-Renaissance equestrian monuments.

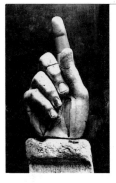

Fragment from a statue of Constantine

Early 4th century AD

Dominating the courtyard of the Palazzo dei Conservatori are a colossal hand, foot and head belonging to a massive statue of Constantine, the first Christian Emperor, which was twelve metres high. Immediately after his conquest of Rome at the Milvian Bridge, Constantine altered and completed the vaulted Basilica of Maxentius in the Forum (page 31) and placed his statue in an enormous apse at the west end of the nave. These fragments were found *in situ* and brought to the Capitoline in 1486 to form part of the early collection of Classical sculpture housed here. Surrounding them are reliefs and inscriptions: one with BRIT is from a triumphal arch celebrating the conquest of Britain by Claudius, and the capture of King Caractacus.

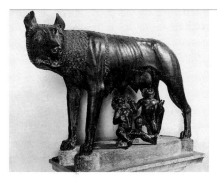

The Capitoline She-Wolf

Late 5th or early 6th century AD

Vulca of Veii (attributed)

The she-wolf suckling the twins Romulus and Remus is an emblem of Rome. History relates that their mother was a Vestal Virgin who had been raped by Mars for which she was thrown into prison and her children into the Tiber, but they survived and were reared by a she-wolf, and Romulus became the legendary founder of Rome. This bronze she-wolf is Etruscan, possibly by the famous Vulca of Veii, from the late sixth or early fifth century BC and it originally stood on the Capitol. It is a wonderful expression of fierceness, intelligence, fear and greed, the qualities with which this animal is associated. The figures of Romulus and Remus were added by Antonio Pollaiuolo (*c.* 1432–98) in order to turn it into an emblem of Rome.

CASTEL SANT'ANGELO

Built AD 135–139

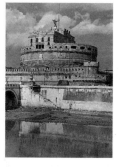

Address
Lungotevere Castello, Roma
© 68.75.036

Map reference
⑦

How to get there
To Ponte Vittorio
Emmanuele, buses 23, 34,
41, 46, 46b, 62, 64, 65, 98,
280, 808, 881, 982

Opening times
Summer daily 9–6. October
to March 9–3 (last tickets at
2). Closed second and
fourth Monday of the month

Entrance fee
L 8,000

The best approach to the Castel Sant'Angelo is across the Ponte Sant'Angelo decorated with Bernini's angels of 1688, but beware of pickpockets. It was built during the reign of Hadrian, but finished after his death as his mausoleum, following the example of Augustus. Originally it was crowned by a mound of earth planted with trees and a tower projected from the middle with either a statue of Hadrian, a four-horse chariot or the great bronze pine-cone now in the Vatican; its base was covered with marble, columns and statues.

Following the Sack of Rome in AD 410, the building was plundered and in AD 590 a virulent plague swept through the city, but as Pope Gregory the Great passed by he apparently had a vision of the Archangel Michael on the top and the plague miraculously stopped. A chapel was built on the spot and the structure renamed. The inside was converted into a fortress with grim dungeons and the Castle now houses a collection of medieval instruments of war. A tunnel linked the Castle to the Vatican, so it could be used by the Popes in times of emergency; there are vast storerooms for oil and grain, a strong room for their treasures and also their private apartments. These were decorated in the Renaissance; one room is known as the Bathroom of Clement VII and has heated walls painted with grotesques by Giulio Romano (1492–1546). It was here that Clement VII was a prisoner in his own city during the Sack of Rome of 1527. There are also the rooms of Paul III decorated by Perino del Vaga (1501–47) and others. Above, Julius II and Paul III built loggias from which to admire the wonderful views. On the top terrace, which is the famous setting for the last scene in Puccini's *Tosca*, is Verschaffelt's eighteenth-century Baroque statue of the Archangel brandishing his sword.

CIRCUS MAXIMUS

The best view of the Circus Maximus is from the Palatine but imagination is needed to reconstruct it from what is now an open strip of grass. It was the first circus in Rome and became the largest, holding, some say, as many as 380,000 spectators. The Emperor sat in a massive box projecting out from the Palatine; the uppermost seating, as high as the Colosseum, was wooden and frequently collapsed killing many, but this did not diminish the popularity of the games, the last of which were held by the Ostrogoth King Totilla in 549. The greatest events were the chariot races which thundered around the central *spina*, still marked out by a bank and cypress trees. Originally, the great obelisk now at the Lateran stood in the centre, and there was a column at each end to mark the turning points of the course. There might be twenty-four races a day with up to twelve chariots participating in each, and progress around the seven circuits of the race was marked out by moving seven large wooden eggs along the spina. Outside, the arcades were filled with shops and bars; it was also the haunt of prostitutes.

Address
Piazza di Porta Capena, Roma

Map reference
⑧

How to get there
To Circo Massimo: Metro B. To Porta Capena: buses 11, 15, 27, 90, 90b, 118, 204, 673. Trams 13, 30b

⭐ COLOSSEUM

Built AD 70–80

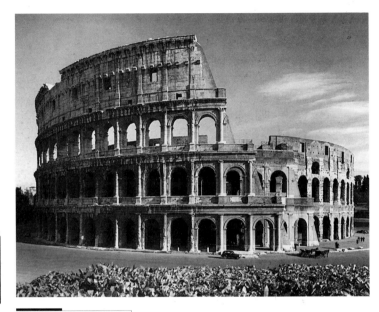

Address
Piazzale del Colosseo,
Roma
✆ 70.04.261

Map reference
⑨

How to get there
To Colosseo: Metro B.
Buses 11. 15, 27, 81, 85, 87,
118, 186, 204, 673
Trams 13, 30b

Opening times
Mon, Tue, Thur, Fri and Sat
9–5. Wed and Sun 9–1. Last
tickets one hour before
closing.

Entrance fee
Interior free. Upper galleries
L 8,000

The Colosseum was built on the site of Nero's ornamental lake in the gardens of his Golden House, and was named after a 120-foot gilded bronze statue of the Emperor which stood nearby. This oval amphitheatre has eighty numbered arches through which the audience entered and it seated some 45,000 people arranged according to their place in society; women were at the top. Opposite the entrance, above the arch where gladiators entered the arena, was the podium for the Emperor, Vestal Virgins and VIPs. A wooden floor formerly covered the pit of corridors where the animals were caged and an elaborate system of mechanical gates and narrow corridors, in which they could not turn, released them into the arena. This was covered in sand to prevent the combatants slipping and to soak up the blood. An enormous awning, which took 1,000 men to raise and lower, protected the audience from the sun. Over the centuries two thirds of the building has been pillaged, but in spite of its ruined state it is not difficult to imagine the sound of the roaring crowd.

Built 8th century BC to 4th century AD

This open space was the heart of ancient Rome where great basilicas, temples and monuments once stood. It was destroyed by barbarians in the fifth century and plundered thereafter. In the nineteenth century cattle grazed and vines grew amongst the ruins, and today a walk through the Forum reveals something of Rome's great past which has inspired poets and artists since the Renaissance.

The Forum was rebuilt many times from eighth century BC to the fourth century AD. On the left of the entrance is the Temple of Antoninus and Faustina, a second-century Emperor and his wife, now rebuilt as a church. Temples were not built to accommodate huge crowds but to be impressive monuments where sacrifices on the steps were a public event. To the right are the stumps of columns of the Basilica Aemelia, a type of building introduced in the second century BC for business transactions, judicial hearings and meetings. Fused to the floor are coins melted in the Sack of Rome of AD 410. In front of this Basilica was the original market place and cutting across is the Via Sacra where processions of victorious generals passed up to the Temple of Jupiter on the Capitoline Hill. Towards the Capitol is the reconstructed Curia, or Senate House; the Lapis Niger, thought to mark the Romulus's tomb; and the Rosta where proclamations were announced. Near the arch of Septimius Severus are the Temples of Concord, Vespasian and Saturn and the huge Basilica Julia. Back in front of the entrance was the Temple of Julius Caesar on the spot where his body was cremated in 44 BC and his will read by Mark Antony.

Along the Via Sacra towards the Colosseum lies the circular Temple of Vesta and the House of the Vestal Virgins (page 30), the Temple of Romulus and the massive Basilica of Constantine (page 31). If you continue round past the Arch of Titus you come to a path up to the Palatine, where a cool drinking fountain and a breeze across the gardens and ruins await you.

Address
Via dei Fori Imperiali, Roma. Entrance in Largo Romolo e Remo
✆ 699 0110

Map reference
⑩

How to get there
To Colosseo: Metro B. To Via dei Fori Imperiali: buses 11, 27, 81, 85, 87, 186

Opening times
Mon to Sat 9–one hour before sunset. Sun and hols 9–1. Last tickets one hour before closing

Entrance fee
L 12,000 (includes Palatine)

FORUM ROMANUM

The Temple of Vesta and the House of the Vestal Virgins

Built 2nd century AD

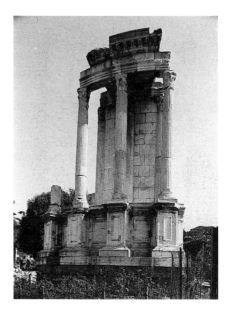

Opposite the entrance to the Forum stand three columns and part of the main wall of the circular Temple of Vesta. This and other Classical prototypes with a circular peristyle (row of columns surrounding the temple) and cella (inner chamber) inspired Bramante's Tempietto (page 96) which, via Palladio, influenced numerous other structures from domes to follies. In Roman times, this temple was of great importance as it contained the sacred and eternal flame guarded by the Vestal Virgins. They were housed beside the Temple in the centre of the Forum as befitted their exalted status. There were six Vestal Virgins, who took their thirty-year vow of chastity aged between six and ten, and were given every honour. However, if one let the fire go out, which signified the fall of Rome, she was whipped by the chief priest. If she broke her vow of chastity, she was walled up with only one candle and a loaf of bread in the 'field of the wicked' and her lover was publicly flogged to death. The House, not unlike a convent, was arranged around a courtyard surrounded by a portico; the kitchen with its ovens is still recognizable, and there were private baths and heating.

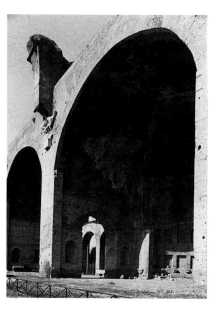

This enormous building is sometimes known as the Basilica of Maxentius as it was begun by the Emperor who died in the famous battle at the Milvian Bridge. It was finished by Constantine and was to be the last great civic building of ancient Rome. Used as a quarry for centuries it has been reduced to about a third of its original size, but the three vast barrel-vaulted arches still dominate the Forum. These were repeated opposite and carried a massive coffered vault which collapsed in 1349 during an earthquake. Unlike in the porticoed basilicas of the Forum, Constantine was inspired by the Baths of Caracalla and Diocletian to use brick and concrete in order to create this impressive structure. The great hall focused on the terminal apse which contained a colossal statue of the Emperor: fragments of his head, hand and foot are now in the Capitoline Museums (page 25). The walls were covered in marble and stucco decoration. One of the eight columns supporting the vaulting still survived in 1614 when Pope Paul V took it to Santa Maria Maggiore (page 78); sixty horses were needed to remove it.

The Arch of Titus
Built AD 81

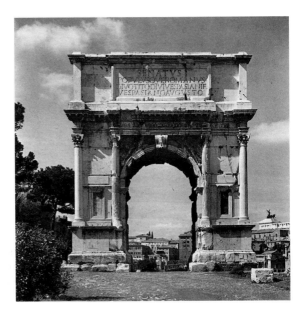

The Arch of Titus stands at the highest point of the Via Sacra, looking across to the Temple of the Emperor and his father, Vespasian. It commemorates Titus's victory over the Jews and his destruction of Jerusalem in AD 70, and is near the Colosseum, built by captives brought back from the campaign (page 28). The attic storey has the dedicatory inscription and the single-arched monument was originally covered with sculpture; there was a bronze group of Titus and Vespasian in a four-horse chariot on the top. Winged victories holding standards are carved in the spandrels; on the frieze is a triumphal procession; inside the arch is deep coffering and a relief of the Emperor being taken to paradise by an eagle. On one side a triumphal procession carries the spoils from Jerusalem, including the seven-branched golden candlestick which God had commanded from Moses; on the other side, the Goddess Rome leads the chariot of Titus as Victory crowns him, with the deities Honour and Courage in attendance.

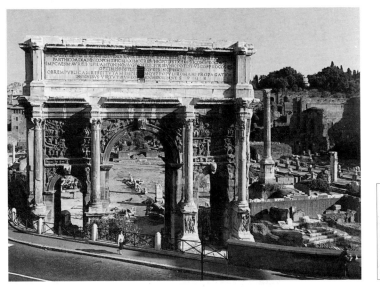

FORUM ROMANUM

Inscriptions on both sides of the arch celebrate Septimius Severus's tenth year as Emperor and the victories in the East of his sons, Caracalla and Geta. Medals show that it was originally crowned by statues of the Emperor and his sons in a chariot of six horses. Geta, however, was murdered by Caracalla who changed the words in an attempt to obliterate his brother's name, but the original can still be seen in the fourth line. The three-arched monument is faced with marble reliefs of Eastern figures paying homage to Rome and captives are shown at the bases of the columns. The winged figures of victory in the spandrels have influenced numerous architects and painters since the Renaissance. The arch stood a short way from the Via Sacra, which was the traditional route for triumphal marches after battle, when successful generals and their legions would proudly carry their booty, followed by their long lines of captives. When the Holy Roman Emperor Charles V visited Rome in 1536, a procession was organized to actually pass through the arch. The construction of the new road involved the demolition of two churches, 400 houses and numerous ancient monuments. Embarrassingly, Charles's chariot got stuck in the climb up to the Capitol.

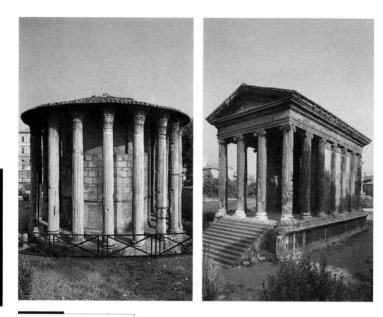

Address
Piazza della Bocca della
Verità, Roma

Map reference
⑪

How to get there
To Piazza Monte Savello:
buses 15, 23, 717, 774, 780
To Via Petroselli: buses 15,
23, 57, 90, 90b, 92, 94, 95,
160, 204, 716, 774, 780

Opening times
Interiors rarely open, but
exteriors can always be
viewed

These two temples stand in what was the cattle
market, the oldest market place of ancient Rome;
near to the river, it was obviously a convenient
landing stage. It is also where the Cloaca
Maxima, the ancient sewer, flowed into the river.
Both temples date from the second century BC
and are among the city's oldest surviving mon-
uments. The rectangular temple, formerly
known as the Temple of Fortuna Virilis, is the
Temple of Portunus, god of harbours, and with
the fluted Ionic columns of the portico contin-
ued as half columns running round the cella, it
is a marvellous example of a temple from the
Republican age. Nearby, the circular temple,
wrongly thought to be dedicated to Vesta
because of similarities with the one in the Forum,
is the Temple of Hercules Victor, identified by
an inscription on the base of a statue found here.
Its circular cella of solid marble is surrounded by
twenty fluted Corinthian columns, but the orig-
inal conical roof and entablature have disap-
peared. Also in the garden is a Baroque fountain
created by Carlo Bizzaccheri in 1717.

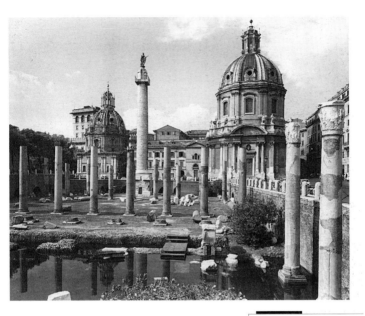

Mussolini laid out the wide Via dei Fori Imperiali from the Piazza Venezia to the Colosseum for military parades, destroying many Renaissance buildings and covering much of Trajan's Forum. It was one of five Imperial fora, along with those of Caesar, Augustus, Vespasian and Nerva. They were built as the Forum Romanum grew too small for the population and new temples, basilicas and shops were needed. The Forum of Trajan was the last to be built and included a temple dedicated to the Emperor, with his equestrian statue in the centre, the huge Basilica Ulpa and Greek and Latin libraries at the west end beside the great Column of Trajan. This commemorated his conquests of the Dacians (who inhabited the area of present-day Romania); a 200-metre spiral frieze running round it records the campaign and includes 2,500 figures. The semi-circular portico faces the Markets of Trajan which consisted of 150 individual shops, and from the Via IV Novembre there is a wonderful view from where it is not difficult to imagine the street lined with shops full of people trading.

Address
Via dei Fori Imperiali, Roma.
Entrance at Via IV
Novembre.
✆ 67.10.30.69

Map reference
⑫

How to get there
To Via IV Novembre: buses
57, 64, 65, 70, 75, 81, 170,
492, 710

Opening times
Winter: Tue to Sat 9–1.30;
Sun and hols 9–1. Closed
Mon. Summer: Tue, Wed
and Fri 9–1.30; Thur and Sat
9–6; Sun and hols 9–1.
Closed Mon.

Entrance fee
L 3,750

Address
Villa Borghese, Piazzale
Scipione Borghese 5, Roma
✆ 85.48.577

Map reference
⑬

How to get there
To Piazzale Brasile/Porta
Pinciana, buses 52, 53, 56,
490, 495, 910

Opening times
Tue to Sat 9–7, (April to
October closes at 1.30). Sun
& holidays 9–1. Closed
Mon.

Entrance fee
L 4,000

The paintings collection is
currently exhibited at the
'Complesso Monumentale
del San Michele a Ripa', Via
di San Michele 22. Tel:
581.16.732 Bus: 23. Tram: 13
Open Tue to Sat 9–7; Sun
9–1. Closed Mon. Entrance
L 4,000

The Villa Borghese is set in Rome's famous public park. It was built for Cardinal Scipione Borghese, Paul V's nephew, and has a typical U-shape design. Originally there was a large double flight of stairs up to the arched loggia with its terrace above. At the back are two three-storey towers for the servants' quarters and in the early seventeenth century each facade was embellished with hundreds of statues, busts and reliefs. The interior walls used to be covered with gold and blue leather until the late seventeenth and early eighteenth centuries, when the Villa was redecorated with marble, stucco and Baroque frescoes. Set into the floor of the massive entrance hall are five mosaics of gladiators fighting and hunting scenes from the third and fourth centuries. The ceiling was frescoed in 1774 by Mariano Rossi with *Marcus Furius Camillus breaking off negotiations with Brennus*.

The Villa houses the magnificent collection of paintings and sculptures begun by the Cardinal with donations from the Pope, with later additions made by members of the family. However, Camillo Borghese, husband of Napoleon's sister, sold the greater part of the archaeological collection – 344 pieces – to the French Emperor in 1807, and these are now in the Louvre in Paris. The current collection includes a *Sleeping Hermaphrodite*; Bernini's earliest work, the *Goat Amalthea* executed before he was seventeen; his busts of *Pope Paul V* and *Cardinal Scipione Borghese* and many of his greatest sculptures. Here too is Canova's masterpiece (page 41). Recently there have been structural problems in the building, and the paintings have been moved and are now on display in Trastevere until the repairs are complete. The collection includes gems by Raphael, Titian, Cranach, Correggio and Caravaggio.

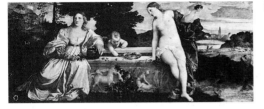

Sacred and Profane Love by Titian (*c.* 1485–1576) has been so called because it appears to be a painting of the same woman, clothed and unclothed, and she has been taken to represent these two aspects of love. However, it is difficult to ascertain which aspect is represented by which figure. On the frieze of the fountain is the coat of arms of Niccolo Aurelio, secretary to the Great Council of Ten in Venice, and on the silver dish is that of the woman he married in May 1514. The figure on the left must be the bride, wearing traditional white and holding roses, the flowers of love. On the right, with Cupid at the well, is naked Venus who blesses the union and is invisible to mortals. Likening Aurelio's wife to the goddess of Love and Beauty, Titian's painting becomes a most romantic commemoration of their wedding.

GALLERIA BORGHESE

The Entombment

1507

Raphael
(Raffaello Sanzio)

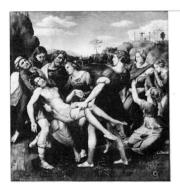

The Entombment by Raphael (1483–1520) was commissioned by Atalanta Baglione for the family chapel in San Francesco at Perugia in memory of her son who had been assassinated. It is an early work, painted before the artist arrived in Rome, and it shows that Raphael was a keen student of other artists. He has combined the influences of Perugino, his master, in the overall layout of the composition and the landscape in the background, and of Michelangelo in the muscular figures of the men carrying Christ, the serpentine figure of the woman twisting round to catch the fainting Virgin, and in the body of Christ, which was inspired by the *Pietà* in St. Peter's and known to Raphael from drawings. No doubt the Perugians were furious when they were commanded by Pope Paul V to send their painting to Rome to become part of the Borghese collection.

GALLERIA BORGHESE

The Lady with a Unicorn

1505–08

Raphael (Raffaello Sanzio)

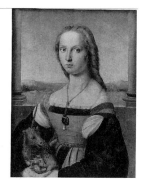

This unidentified fashionable lady was painted during Raphael's time in Florence, where he had gone to study the works of Leonardo da Vinci and Michelangelo. Following the design of the *Mona Lisa* (Louvre, Paris), she is seen sitting in half-length, turning slightly to her right, set against a loggia with a landscape beyond. In her arms she holds a young unicorn which might have been part of her family crest, but Raphael (1483–1520) may have meant to give the portrait a romantic interest. According to myth, this beautiful, small white pony with a single horn was extremely swift but it could be caught by being lured to a virgin, whose purity it could sense. The unicorn was therefore associated with courtly love and was likened to a man who becomes the helpless servant of the noble lady he loves.

Boy with a Basket of Fruit

c. 1594

Caravaggio
(Michelangelo Merisi)

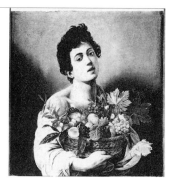

Early in his life, Caravaggio (1571–1610) painted many half-length young boys offering wine, or holding fruit, flowers or musical instruments. Like the *Sick Bacchus*, also in the collection, it is thought that they are idealized self-portraits. Here the composition is very straightforward; the boy is set against a neutral background and is lit by a gentle light. His pose is confident yet he seems to hesitate and his gaze is both innocent and knowing. While the figure is not so skilfully painted, the fruit in the basket shows remarkable technical ability. Caravaggio probably trained as a still-life painter in Lombardy, and later said 'it requires as much skill to paint a good picture of flowers as one of figures'. This type of painting was sold cheaply on the streets of Rome, which is probably how the artist funded the beginning of his career when he arrived in the city in about 1592.

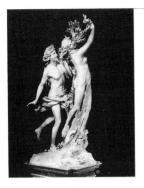

Cardinal Scipione Borghese commissioned this sculpture to be placed against a wall in his villa, where it would have been seen only from the front. The story from Ovid tells how Daphne, the daughter of a river-god, was pursued by Apollo until she could run no more; she cried to her father for help and he transformed her into a laurel tree. It was a popular subject in painting but was difficult to portray in stone. Bernini (1598–1680), however, describes the chase and metamorphosis with apparent ease. Swift movement is conveyed by the strong upward diagonal of Daphne's outstretched arms from which she turns in horror as the branches begin to grow, while roots spring from her feet and bark envelops her legs.

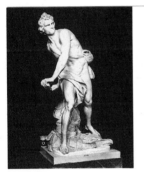

Bernini (1598–1680) carved *David* when he was only twenty-five, and it took him a mere seven months to complete. He chose to depict the dramatic moment just before the Old Testament hero releases the stone from his sling to slay Goliath. With his feet set wide, he twists round in vigorous movement, and his knotted brow and tightly clenched mouth express the concentrated effort required to overcome the giant; apparently Bernini looked at his own face in a mirror to study the expression. *David* was the last large-scale piece for the Villa Borghese and like some of the other sculptures should be seen against a wall; its greatest impact is from the point where an imagined Goliath stands behind the spectator, who then becomes included in the action. *David* represents the beginning of the exaggerated, theatrical effects of Baroque art.

The Rape of Proserpine

1621–22

Gianlorenzo Bernini

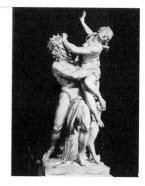

Proserpine was picking flowers in a meadow when she was spotted by Pluto, king of the underworld. Immediately, he fell in love and carried her down to his kingdom below. This interpretation by Bernini (1598–1680) is startlingly dramatic as Pluto takes great strides with Proserpine struggling to break free from his grasp. She cries in vain for they have already arrived at the gates of Hades, guarded by Cerberus, the three-headed dog, which here also acts as a structural support for the group. Bernini's technical virtuosity is outstanding: in marble he describes a hand sinking into a soft thigh, different textures of skin and hair and Proserpine's tears. Commissioned by Cardinal Scipione Borghese for his villa, the group was originally set against a wall but it demands to be placed in the centre of the room where it can be admired from every angle.

Aeneas and Anchises

1618–19

Gianlorenzo Bernini

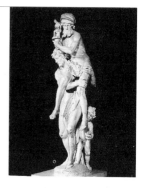

Aeneas and Anchises was the first large-scale work by Bernini (1598–1680) and also his first commission for Cardinal Scipione Borghese. It was executed when he was nineteen and was completed in one year. The life-size group is from Virgil's *Aeneid* and depicts the scene when Aeneas carries his father Anchises and leads his son Ascanius out of burning Troy. Anchises holds the sacred relics and their home-gods. The subject was popular as it illustrated the noble values, family respect and religious piety of Aeneas, whose descendants founded Rome. The work was inspired by figures in Michelangelo's and Raphael's paintings, but translated into marble the group appears top-heavy and somewhat unstable. However, the contrast of types of the three ages of man is highly naturalistic and anticipates Bernini's later works.

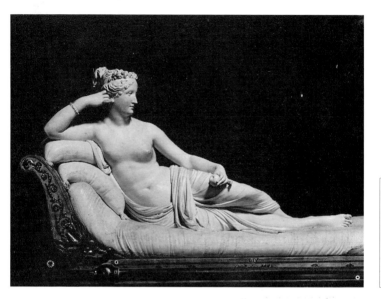

GALLERIA BORGHESE

Napoleon Bonaparte's favourite sister, Paulina Borghese, reclines half-draped on an Empire couch in the guise of Venus, holding in one hand the golden apple she received from Paris for her beauty. Antonio Canova (1747–1822) has carved her delicate features and perfect form which were once so famous in the Neoclassical style.

Paulina was a manipulative minx. She was outstandingly vain, vastly extravagant, and surrounded herself with admirers and a procession of lovers. She liked to use her ladies-in-waiting as foot-stools, warming her feet on their bosoms, and to be carried to and from her bath, wrapped in a towel, by a gigantic negro. As she held court, a naked boy covered in gold would spray her with scent. Her only redeeming feature appears to have been her devotion to her brother; she gave him all her jewelley when he was in need and her diamonds were found in a secret drawer of his travelling coach at his defeat at Waterloo. In 1803 Napoleon arranged for his wayward twenty-three-year-old sister to marry for the second time the enormously rich Prince Camillo Borghese. Soon afterwards Canova was given this commission. Later, it was said that the Prince guarded it jealously letting few people see it, preferring to look at it at night, lit only by a single candle. Paulina sat for it at her own suggestion and the half-naked statue caused quite a scandal. When one lady asked her how she could possibly have posed like that, the reply was 'Oh, but the studio was heated'!

Address
Piazza del Collegio Romano
1a, Roma
℡ 67.94.365

Map reference
⑭

How to get there
To the Piazza Venezia:
buses 44, 46, 56, 57, 60,
64, 65, 70, 75, 81, 85, 87,
90, 90b, 95, 160, 170, 181,
186, 204, 492, 710, 718, 719

Opening times
Mon, Tue, Fri, Sat & Sun
only 10–1

Entrance fee
L 5,000 for Gallery, plus
L 5,000 for Royal
Apartments.

Tours
Guided tours of the
apartments daily at 11 and
12.

The massive Palazzo Doria beside the Corso covers an area almost as big as the Colosseum and, at one time, contained more than 800 people. It was originally built in the fifteenth century for the Dorias of Genoa, and later passed into the possession of the Pamphilj family. The Pamphilj Pope Innocent X plundered papal revenues to endow a dynasty aided by his rapacious sister-in-law Olimpia. In the last ten days of his life she collected half a million crowns selling benefices in his name and, as he lay dying, she dragged out two coffers full of money hidden beneath his bed, yet she claimed she was too poor to pay for his funeral. She gave these funds to her son Camillo with which he acquired the Palazzo Doria Pamphilj and built the largest villa in parkland northwest of Rome.

The Palace houses a great family art collection: Velázquez's painting of Innocent X and Bernini's bust of him are its greatest treasures. A custodian will hand out a catalogue to be returned at the end of the visit. The pictures are exhibited on the first floor in four long rooms running around the garden court and in a series of rooms running along the length of the palace on the side of the Corso. There is also the Salone Aldobrandini with Classical works, tapestries and paintings. Canvases by Bellini, Titian, Andrea del Sarto, Caravaggio, Allori, the Carracci, Guido Reni, Bruegel the Elder and Younger and Claude Lorrain are set between mirrors and furniture gilded and covered in Genoese velvets, which still gives an idea of the sumptuousness of the eighteenth-century palace.

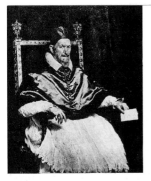

Innocent X ⭐

1650

Diego Velázquez

Velázquez (1599–1660) came to Italy for the second time in 1649 to buy Italian paintings and sculptures for the Spanish royal collections. He most admired Venetian painting, Titian above all, and went first to Venice. He arrived in Rome in the Jubilee year of 1650. Although Innocent X disliked painters and said they did nothing but annoy and deceive him, he agreed to be portrayed as Julius II had been by Raphael and Paul III was by Titian. Unlike Bernini, Velázquez reveals the Pope's unattractive features and the image suggests a man of reserved but resolute character. The masterly loose handling of paint and sumptuous colour led Sir Joshua Reyolds to describe it as the finest picture in Rome, and its intensity inspired the several terrifying image of screaming Popes by Francis Bacon.

GALLERIA DORIA PAMPHILI

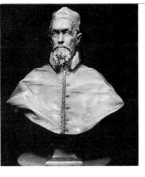

Bust of Innocent X

c. 1647

Gianlorenzo Bernini

As Bernini's projects became increasingly large, particularly at St. Peter's, which occupied him from 1623 until his death, he had little time for smaller works. He would only carve portrait busts of the most important, and Innocent X was the last Pope to be portrayed by the sculptor. Bernini (1598–1680) apparently once said that a realistic portrait was one which saw a unique quality in each person, but that a beautiful not ugly feature must be chosen. When Innocent X was elected to the Papacy he was an uncommunicative and mistrustful old man, but Bernini has flattered him, making him look noble. The swirl of drapery indicates movement and gives him a commanding air which is entirely appropriate for a man in such high office.

GALLERIA DORIA PAMPHILJ

Rest on the Flight into Egypt

c. 1595

Caravaggio (Michelangelo Merisi)

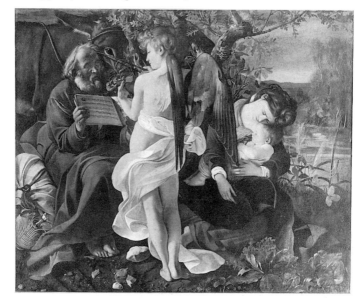

The Rest on the Flight into Egypt is an unusually complex composition for an early work by Caravaggio (1571–1610) and one of the very few landscapes he painted. From small-scale, single figures of a secular subject, set against a plain background, he turned to altarpieces of figures, grouped in highly imaginative arrangements. Contemporaries reported that he worked directly onto the canvas without preparatory drawings in the Venetian manner, but he must have studied his models carefully. The figures are set in a landscape surrounded by naturalistic details meticulously rendered as in many of his still-lifes.

While Caravaggio's later works are often highly dramatic, this scene is one of gentle lyricism. Joseph was warned in a dream that Herod was planning to kill the infant Christ and, as the Holy Family rest on their escape, he has a vision of an angel sweetly playing the violin. Seen from the back, the angel is inspired by Classical statues and is draped provocatively with a white cloth. Sitting on a sack-like saddle bag, Joseph holds up the musical score, on which the notes are legible. With one foot on top of the other, his pose is clumsy but his expression devout. Beside him the Virgin tenderly embraces her Child. In this picture Caravaggio shows himself to be a master of human psychology.

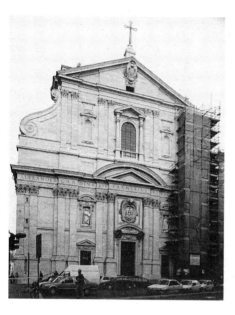

This is the principal Jesuit church in Rome and its facade, plan and decoration are important landmarks in the development of the Baroque, providing a model for numerous churches throughout Europe. The facade shows a complex use of classical elements, coupling and superimposing details to give depth to the surface. Inside, the church is longitudinal with an apse as in early basilicas and, since there are no aisles, all concentration is on the altar. But the plan is also cross-shaped with transepts; the right one is dedicated to St. Francis Xavier, one of the first Jesuit missionaries, and the left to St. Ignatius Loyola, founder of the movement in 1540. The latter is commemorated in a sumptuous late seventeenth-century tomb and altar by Andrea Pozzo (1642–1709) and others, which is covered with marble, bronze and lapis lazuli. The group of the Trinity has a globe formed from the largest known piece of lapis lazuli. In front of the altar statues represent Religion triumphing over Heresy and Barbarians adoring the Faith. The explosive ceiling decoration of the nave shows *The Worship of the Holy Name of Jesus* by Baciccia (1639–1709).

Address

Piazza del Gesù, Roma

✆ 678 63 41

Map reference

⑮

How to get there

To Piazza Venezia: buses 44, 46, 56, 57, 60, 62, 64, 65, 70, 75, 81, 85, 87, 90, 90b, 95, 160, 170, 181, 186, 204, 492, 710, 716, 718, 719

Opening times

Daily 6–12 and 4–7

HADRIAN'S VILLA

Built AD 118–134

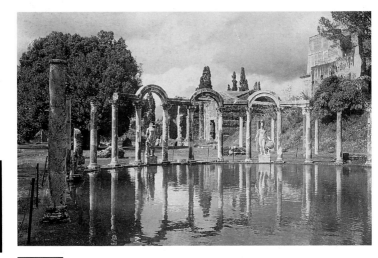

Address
Villa Adriana, Via Tiburtina, Tivoli
✆ 0774/53.02.03

Map reference
⑯

How to get there
Mainline train on Rome–Avezzano line to Tivoli then local bus 4, or COTRAL bus from Rebibbia (on Metro line B)

Opening times
Daily 9–90 mins before sunset. Last admission 1 hour before closing. Closed on public holidays

Entrance fee
L 8,000

Hadrian's Villa lies in a valley some thirty kilometres from Rome, just off the road to Tivoli. Its massive ruins are more like those of a city than a palace, covering an area of about 150 acres. Originally it may have been far larger. At the entrance there is a model of how it would have looked before it was ransacked, which is worth studying in order to understand the layout of the villa complex. It was built for the Emperor's retirement; he wanted to devote the last days of his life to painting, music, poetry and literature. Hadrian reconstructed the famous monuments he had seen on his travels in the Eastern Empire, no doubt to remind him of his youth. There was the Greek Theatre, the Stoa Poikile from Athens; the 'Canopus', a copy of an Egyptian sanctuary in the valley of the Nile with great pools and sand which was artificially heated in the winter; and the curiously named Maritime Theatre, enclosed with high walls for privacy and placed on an island with a circular moat reached by a bridge on rollers. There were also numerous libraries, large and small *thermae* or baths, an Academy and the barracks of the Praetorian Guard.

At the bottom of the Spanish Steps is the house in which, in a tiny room overlooking the Piazza, John Keats died on 23 February 1821, aged twenty-five. Like many others, he had come to Rome for his health but the more temperate climate could not cure the tuberculosis he had contracted from his brother, whom he had nursed until he died in his arms. The house is now a museum devoted to the Romantic poets: Keats, Shelley, Byron and their circle. It contains letters, manuscripts and a fine library as well as mementoes such as Byron's wax carnival mask and copies of Keats's bank statements, which reveal the poverty in which he died.

The museum is located on the second floor where Keats rented cheap lodgings with meals provided by a Signora Petri, one of which he apparently threw out of the window. From his room he would have heard the sound of the fountain and bustle of the Piazza. The fireplace which lit the ceiling at which he stared remains; the furniture and all his possessions were burnt to prevent contagion. His devoted friend, the painter Joseph Severn, stayed with him to the end and sketched him lying asleep; his death mask was taken three days after he died, when after months of agony his wasted face at last had a tranquil smile. Severn also painted the portrait of the young Percy Bysshe Shelley writing his *Prometheus Unbound* perched high up on the ruins of the Baths of Caracalla.

Both Keats and Shelley are buried in the beautiful Protestant Cemetery, near the Porta San Paolo. By Keats's own request 'Here lies one whose name was writ in water' was carved on his gravestone. The following year, Shelley's ashes were brought to the cemetery to join the grave of his infant son, William; Shelley had drowned off the coast near Viareggio and when his mutilated body was found several days later, in one of his breast pockets was a volume of Keats's poetry, doubled back as if he had been interrupted while reading.

Address
Piazza di Spagna 26, Roma
© 678 42 35

Map reference
⑰

How to get there
To the Piazza di Spagna:
Metro A. Bus 119. To Piazza
San Silvestro: bus 52, 53,
58, 58b, 61, 62, 71, 81, 85,
90, 90b, 160

Opening times
Winter: Mon to Fri 9–1 and
2.30–5.30. Summer: Mon to
Fri 9–1 and 3–6. Closed Sat
and Sun.

Entrance fee
L 5,000

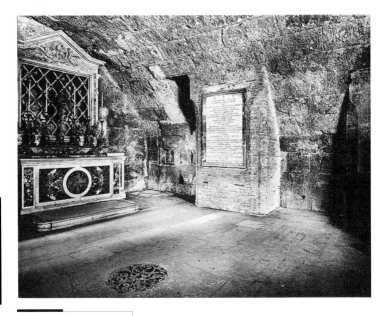

Address
Clivo Argentario, Roma
☎ 67.10.30.69

Map reference
⑱

How to get there
To Piazza Venezia: buses
44, 46, 56, 57, 60, 64, 65,
70, 75, 81, 85, 87, 90, 90b,
95, 160, 170, 186, 493, 710,
716, 718, 719

Opening times
Daily 9–12.30 and 2.30–6

Entrance fee
Donation expected

A flight of steps leads down from the Campidoglio giving a wonderful view across the Forum to the Palatine. At the bottom on the left is the church of San Giuseppe il Falegname (St. Joseph the Carpenter) built in 1598. Stairs lead down underneath the church to the Tullianum or Mamertime Prison, so named in the Middle Ages and consecrated as the Chapel of San Pietro in Carcere (St. Peter in Chains). It may have originally been a cistern and in Roman times it was used as a dungeon; inmates were flung through the hole into the grim chamber to wait for death by starvation or execution. On the walls are the names of the famous who suffered here including, according to Christian tradition, St. Peter and St. Paul. The story of how St. Peter was rescued by an angel is wonderfully illustrated by Raphael in the Stanze of the Vatican.

Built AD 298–306
Cloister built c. 1560

The Museo delle Terme is housed in what were originally the Baths of Diocletian (page 21). These were vast, covering thirty-two acres and allowing 3,000 people to bathe at the same time. There were baths of all temperatures, swimming pools, bath tubs, shaded gardens, gyms, rooms for relaxation, libraries and art galleries, and the whole was surrounded by shopping arcades. A Charterhouse was built into the ruins; the great cloisters with colonnades and fountains are attributed to Michelangelo (1475–1564). The Museum was founded after the Unification of Italy in 1870 as the national collection of antique art, and these imposing ruins are an appropriate setting as the halls and gardens are not unlike those for which the works were originally intended.

Most of the pieces in the museum were discovered this century, apart from those in the Ludovisi collection, with its beautiful fifth-century BC throne probably dedicated to Aphrodite. The largest collection of Roman and Christian sarcophaghi in the world is housed here. There are also wonderfully fine mosaics, one with pygmies hunting hippopotomus and crocodile; Roman terracottas; an altar from Ostia sculpted with the legend of Romulus and Remus; a *Discus Thrower* and a *Sleeping Hermaphrodite*. Trompe l'oeil frescoes from the Empress Livia's Villa at Prima Porta are also on show. They came from what is known as the 'Garden Room' and show trellises of flowers, and trees laden with fruit and birds. On display too are the Farnesina stuccoes and paintings found in a villa on the banks of the Tiber which, because of their Egyptian style, was thought to be where Caesar kept Cleopatra.

For many years the museum has been under restoration and only certain rooms have been open. It is hoped that some of the works will soon be moved to a new museum site in the former Palazzo Massimo alle Terme in the Piazza dei Cinquecento.

MUSEO DELLE TERME

Address
Vla Enrico de Nicola 79,
(Piazza dei Cinquecento),
Roma
☏ 48.82.364

Map reference
⑲

How to get there
To Termini: Metro A and B.
To Piazza della Repubblica:
Metro A. To Piazza dei
Cinquecento: 3, 4, 9, 14, 16,
27, 36, 36b, 57, 64, 65, 75,
93b, 105, 110, 170, 310, 317,
319, 516, 517, 613, 714, 910.

Opening times
Tue to Sat 9–2; Sun and
holidays 9–1. Closed Mon.
Last ticket one hour before
closing

Entrance fee
L 12,000

C. 300 BC–AD 300

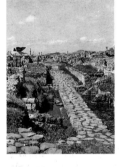

Address
Viale dei Romagnoli 717,
Ostia
✆ 56.51.405

Map reference
⑳

How to get there
To Ostia Antica: Metro B to
Magliana then Ferrovia
Urbana

Opening times
Excavations: Winter Tue to
Sun 9–4.30, Summer Tue to
Sun 9–6. Closed Mon. Last
ticket one hour before
closing. Museum: Daily 9–2

Entrance fee
L 8,000 to excavations and
museum

Ostia was a thriving commercial port and the naval base of Republican Rome. It was situated at the mouth of the Tiber and all Rome's imports, mostly grain which was vital for the survival of the city, and her exports, were carried along the busy Via Ostiensis. However, the sea receded and a new port was planned by Augustus, built by Claudius and Nero and enlarged by Trajan in the first century AD. These ruins, like those of Pompeii and Herculaneum, evoke every day life in an ancient city.

Although various sites on the excavations have been labelled, it is worth trying to get a map, either at the ticket office or at the museum, where many remains are now housed. The entrance to Ostia begins just outside the city walls where the Via delle Tombe is lined with graves. Through the Porta Romana begins the Decumanus Maximus, the main street running through the city. On the right are the Baths of Neptune decorated with mosaics showing the god, and from the top is a beautiful view across to the Alban Hills and the mouth of the Tiber. Further on is the amphitheatre enlarged in the second century AD, which could hold 27,000 people. Behind is the Square of the Guilds where marks in the mosaic floor of the arcade indicate the trades of ship builder and repairer, docker, salvage man and customs official.

In the centre of Ostia is the Forum with its principal public buildings and temples, surrounded by baths, a basilica and curia. Further out are massive warehouses, streets of food shops and wine stores. The middle and lower classes lived in *insulae* or flats, often above a row of shops, and these blocks were made of brick with little decoration and were often four storeys high, reached by a wooden staircase. A few houses of the rich survive with atrium, peristyle, mosaic floors, colonnades and delightful loggias. One entertaining sight is the open plan public lavatories near the Baths of the Forum.

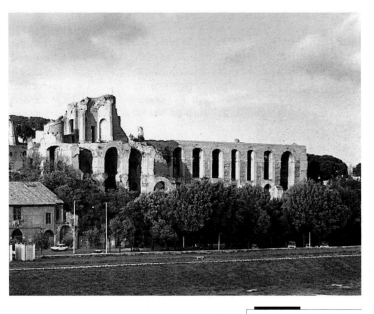

The Palatine hill was where the Emperors resided from the first century AD. It was also the birthplace of Rome; until fourth century AD an altar marked the Lupercal, where the she-wolf suckled Romulus and Remus. Temples were built on the Palatine but no public buildings, and during the Republic it became the residential quarter of the aristocracy. Today all that can be seen is a series of ruins in an attractive landscape setting.

Augustus was born on the Palatine and when he became Emperor he saw no reason to move and continued to live modestly, possibly in the so-called House of Livia which still has beautiful frescoes. Tiberius built the first Imperial Palace here even though he preferred Capri; Caligula, Claudius and Nero also built, but a fire in AD 80 destroyed the area. Domitian built an enormous royal palace in AD 85–89 in two distinct parts. The Domus Flavia was the official palace, with basilicas, dining rooms, audience room and throne room, and the Domus Augustana was the private Imperial palace. What is known as the Stadium may have been a hippodrome or else an enormous sunken garden.

Address
Via San Gregorio, Roma
℡ 699 0110

Map reference
㉑

How to get there
Entrance is from the Forum Romanum. To Colosseo: Metro B. To Via San Gregorio: buses 11, 15, 27, 118, 204, 673. Tram: 13, 30b.

Opening times
Winter: Mon, Wed to Sat 9–3; Sun and Tue 9–1. Summer: Mon to Sat 9–one hour before sunset. Sun and hols 9–1.

Entrance fee
L 12,000 (included in ticket

PALAZZO BARBERINI
(GALLERIA NAZIONALE D'ARTE ANTICA)
Built 1624–33

Address
Via delle Quattro Fontane
13, Roma
℡ 48.14.591

Map reference
㉒

How to get there
To Piazza Barberini: Metro
A. Buses 52, 53, 56, 58,
58b, 60, 61, 62, 95, 116, 119,
204, 492

Opening times
Tue, Thur, Sat 9–5; Wed, Fri
9–2; Sun 9–1. Closed Mon

Entrance fee
L 8,000

The massive Barberini Palace was begun in the second year of Urban VIII's papacy and was the official residence of the papal family. Carlo Maderno's plans combined a commanding palace facing the built-up area of the city and a suburban villa with wings projecting onto vast gardens at the back. The design of the windows at the top, the stairs and some doorways is attributed to Borromini (1599–1669). His rival, Bernini (1598–1680), is also thought to have been involved in architectural work at the Palace; he probably designed the monumental stairs leading up to the gallery on the first floor. On his election the Pope apparently summoned Bernini and said 'Your luck is great to see Cardinal Maffeo Barberini Pope, Cavaliere; but ours is much greater to have Cavaliere Bernini alive in our pontificate.' The bust of Bernini's great friend and patron can be seen inside, as well as the remarkable Baroque ceiling by Pietro da Cortona, which was commissioned when the building works were nearing completion (page 51).

In 1949 the Palazzo Barberini was purchased by the state for the Galleria Nazionale d'Arte Antica (National Gallery of Classical Art) which had been founded in 1895 and housed at the Palazzo Corsini alla Lungara. Other private collections of grand Roman families were added by bequest and purchase and the Gallery now boasts about two thousand paintings. The majority of these are from the Italian Renaissance and Baroque and include works by Filippo Lippi, Raphael, Lorenzo Lotto, Bronzino, Tintoretto, Caravaggio and Guido Reni, but there are also works by El Greco, Nicolas Poussin and a portrait of Henry VIII in the clothes he wore for his marriage to Anne of Cleves in 1540, attributed to Hans Holbein.

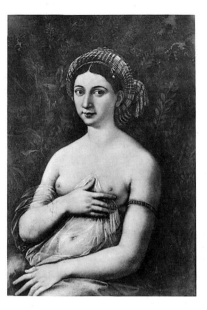

The painting known as *La Fornarina* (the baker's daughter) is thought to be of Raphael's lover and has been attributed to both the artist and his pupil Giulio Romano; the inscription 'Raphael' on her arm could refer either to Raphael's authorship or to his possession of the sitter. An x-ray of the painting has shown that the background was originally a landscape, but the dark leaves now surrounding her give a more intimate impression, suitable for private admiration; seventeenth-century inventories reveal that the picture once had shutters. It has also been suggested that it is a portrait of a courtesan, and her features match a description of one of the best-known in Rome, Beatrice of Ferrara, whom Raphael (1483–1520) was known to have painted. Her widely spaced eyebrows were commented on as well as her eyes that were 'as black as crows', her coral lips, neck of alabaster, firm young breasts and plump, soft body made for pleasure.

It seems highly likely that Raphael enjoyed the company of the beautiful courtesans of Rome. According to his biographer, Giorgio Vasari, he was very fond of women and 'he continued his secret pleasures beyond all measure'. After an unusually wild debauch he returned home with a severe fever, but did not wish to confess the cause of his disorder, from which he died aged thirty-seven. Beatrice made her lovers believe they were in paradise, but like many in her profession, she contracted syphilis, which soon crippled her.

1633–39

Pietro da Cortona (Pietro Berretini)

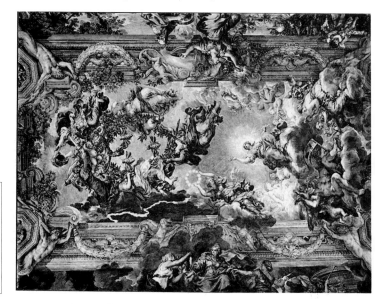

The programme for the decoration of the Barberini Palace was devised by the poet Francesco Bracciolini and Pietro da Cortona's staggering Baroque ceiling in the great reception room is a glorification of the Papacy of Urban VIII (1623–44). In sumptuous colours the ceiling opens to the sky and figures soar upwards or tumble into the room in what appears to be a remarkable amount of space. In the centre, receiving the starry crown of Immortality, Providence reigns through Urban's papacy and she hails the Barberini insignia with its three enormous bees held up by Faith, Hope and Charity. Although the entire ceiling is fresco, the architectural structure which divides the outer edge is illusionistic stucco on which figures struggle overlapping and linking the scenes. These illustrate the virtuous policies of the Pope and his family; on one of the longer sides, Peace sits enthroned while Vulcan at his forge makes shovels not swords and Fury lies chained to the ground. Opposite, Wisdom triumphs over Vice, depicted as the fat, drunken Silenus, and also over Profanity as Chastity condemns Venus and her cupids. The shorter scenes show wise Minerva repelling the Titans and opposite, Hercules driving off the Harpies while Abundance and Magnanimity hand out gifts to the people. Hanging on the walls are seven cartoons for tapestries, now in the Vatican, designed by the school of Pietro da Cortona with scenes from the life of Urban VIII.

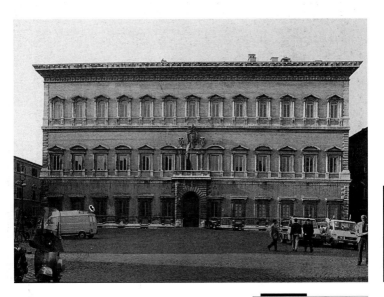

Dominating the Piazza Farnese, with its fountain basins from the ruins of the Baths of Caracalla, is the massive Palazzo Farnese, the most magnificent example of a High Renaissance palace in Rome. It was begun for Cardinal Alessandro Farnese, later Paul III, by Antonio da Sangallo (1455–1534) following the plan of a Florentine palace – a three-storey square block designed round a courtyard – and it was impressive more for its scale than its architectural details. After the architect's death, Michelangelo (1475–1524) heightened the upper storey and added the massive cornice and the more inventive, larger central window. The open loggias at the back of the Palace can be seen through the gates where once the gardens led down to the river.

The Palazzo Farnese has been the French Embassy since 1871 and is not open to the general public. However, with persistence and a telephone call to the Embassy a visit can be arranged to see the classical vestibule which leads into the courtyard, and a few rooms, notably an enormous Salon and Annibale Carracci's ceiling of 1597–1604 showing the loves of gods and goddesses.

Address
Piazza Farnese, Roma

Map reference
㉓

How to get there
To Largo Argentina: buses 44, 46, 56, 60, 62, 64, 65, 70, 75, 81, 87, 90, 90b, 94, 170, 181, 186, 204, 492, 710, 718, 719

Opening times
Entrance only by appointment. Contact French Consulate.

PALAZZO VENEZIA

(MUSEO DEL PALAZZO VENEZIA)
Built 1455, finished 16th century

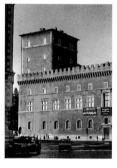

Address
Via del Plebiscito 118, Roma
℃ 67.98.88.65

Map reference
㉔

How to get there
To Piazza Venezia: buses
44, 46, 56, 57, 60, 62, 64,
65, 70, 75, 81, 85, 87, 90,
90b, 95, 160, 170, 181, 186,
204, 492,710, 718, 719

Opening times
Tue to Sat 9–1.30; Sun and
holidays 9–1. Closed Mon

Entrance fee
L 8,000

The Palazzo Venezia began as the modest residence of Cardinal Pietro Barbo, next to his church of San Marco. The windows grouped more closely on the left of the main facade are from the first building project. However, when he became Pope Paul II in 1464, Barbo extended the palace, surrounding the church; unfortunately it is now rather overshadowed by the Victor Emmanuel Monument. The Pope also restored San Marco and made it the national church of his fellow Venetians, whose patron saint is Mark. With its tower and crenellations, the Palace retains the appearance of a medieval fortress, but it also has a beautifully proportioned Renaissance loggia round to the left from which the Pope used to give benedictions to the crowd in the Piazza. In the latter half of the sixteenth century it became the Venetian Embassy, and from 1797 to 1915 it was the Austrian Embassy, Venice having been annexed to the Austrian Empire. In 1929 Mussolini made it his official Headquarters and gave many of his famous speeches from the balcony of the central window.

The collection of the Museum of the Palazzo Venezia is housed in several of the rooms of the papal apartments, largely restored in 1916. In contrast to the exterior, Paul II lavishly decorated the interior with tapestries and gold and silver plate. The museum today is largely devoted to Medieval and Renaissance applied arts There are majolica and porcelain, silverware, tapestries and textiles, weapons and furniture, as well as paintings from thirteenth to the sixteenth centuries and sculptures, bronzes and ivories. The Palazzo Venezia provides a rare opportunity to see the inside of a Renaissance palace and the atmosphere is more like a private collection than a public museum. Special exhibitions are also held here.

This eccentric palace with its doors and windows like the gaping jaws of monsters was built as the studio and residence of the artist Federico Zuccaro (1540/1–1609). The Umbrian artist and his older brother, Taddeo, were highly popular in Rome at the end of the sixteenth century. They decorated rooms in the Palazzo Farnese at Caprarola and the Sala Reggia in the Vatican Palace. Federico travelled to England in 1574 where he apparently painted the Queen and her court, and from 1585 to 1588 he worked at the Escorial for King Philip II of Spain. When the Academy of St. Luke (an association of painters) was founded in Rome in 1593 Federico was elected its first President, and its gatherings were held in this house. Sir Joshua Reynolds lived here in 1752–3 and Wincklemann from 1755 to 1768. In 1900 the house was bought by Enrichetta Hertz, who left it with her library to the German government. It is now the private Biblioteca Hertziana, one of the finest art history libraries in the country.

Address
Via Gregoriana, Roma

Map reference
㉕

How to get there
To Piazza di Spagna:
Metro A. To Piazza San
Silvestro: buses 52, 53, 58,
61, 62, 71, 81, 85, 90, 90b,
160

Opening times
Not open to the public

★ THE PANTHEON

Built AD 120–125

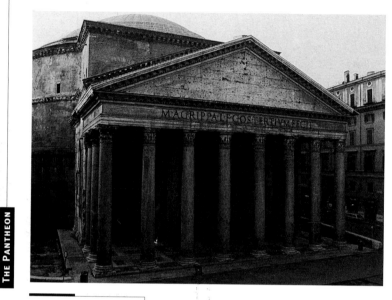

Address
Piazza della Rotonda, Roma
✆ 68.30.02.30

Map reference
㉖

How to get there
To Largo di Torre Argentina:
buses 44, 46, 56, 60, 62,
64, 65, 70, 75, 81, 87, 90,
90b, 94, 170, 181, 186, 204,
492, 710, 718, 719

Opening times
Mon to Sat 9–4.30 (during
July and Aug 9–6). Sun and
holidays 9–1

Entrance fee
Free entry

Originally, a flight of steps led up to the Pantheon's massive portico consisting of eighteen monolithic Corinthian columns of Egyptian granite. The inscription in the frieze claims that it was constructed by Agrippa who built a Pantheon as part of a large thermal complex. The present structure, however, was built by Hadrian. Inside the portico there are holes in the columns where beams were fixed to support huts and covers for stalls as, in medieval times, it was used as a market. Until 1632 the ancient bronze ceiling survived, but it was taken by Urban VIII, the Barberini Pope, for Bernini's baldacchino at St Peter's and for cannons at the Castel Sant'Angelo. The huge bronze doors are original and lead into an architectural wonder, a massive hemisperical dome lit only by an open oculus. The Temple was dedicated to all the gods and the recesses originally contained their statues. The Pantheon was consecrated as Santa Maria ad Martires in 608; Raphael was buried here as well as the first two Kings of United Italy.

At the top of the Via di Santa Sabina on the Aventine is the charming Piazza dei Cavalieri di Malta, decorated with small obelisks and trophies and tall cypress trees. The Piazza is famous for the wonderful view through the keyhole in the the door of the Priorato di Malta, where the dome of St. Peter's can be seen at the end of an avenue of trees. Giambattista Piranesi (1720–78) is better known for his romantic engravings of Rome which were very popular with English visitors and, although he trained as an architect, he designed only this Piazza and the church of Santa Maria del Priorato (1764–65) nearby. The Priorato was the residence of the Grand Master of the Knights of Malta. This order was founded in 1113 as the Knights of St. John, to protect and help pilgrims; their headquarters are now at 68 Via Condotti, where the palace has rights to issue its own number plates and passports because it is the smallest sovereign state in the world.

Address
Piazza dei Cavalieri di Malta, Rome

Map reference
㉗

How to get there
To Via di Santa Sabina: bus 94. To Circo Massimo: Metro B.

Laid out 1644–55

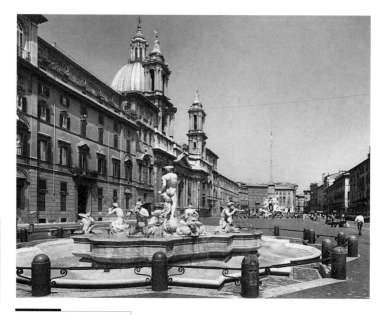

Address
Piazza Navona, Rome

Map reference
㉘

How to get there
To Largo Argentina: buses
44, 46, 56, 60, 62, 64, 65,
70, 75, 81, 87, 90, 90b, 94,
170, 181, 186, 204, 492, 710,
718, 719

Piazza Navona is one of the most wonderful sights in Rome. Its oblong shape, with one straight end and one curved, exactly covers the gound plan of the Stadium of Domitian. Thirty thousand spectators witnessed athletic displays in the arena, inaugurated in AD 86, and until the mid fifteenth century, tournaments and bull-fights were seen from its ancient seats. During the reign of Pope Sixtus IV (1471–84) the Piazza became a market place and it was plundered for the foundations of new Renaisance buildings, but the remains of an entrance gate can be seen on its northern edge in the Piazza di Tor Sanguigna. Today the palaces and churches which surround the Piazza replace the tiers of seats. To cele-brate his Papacy (1644–55), Innocent X trans-formed the Piazza; under his patronage Borromini began Sant'Agnese (page 62), and completed his palace south of the church, and Bernini designed the Four Rivers Fountain, the most splendid of the three in the Piazza (page 59). From 1651 to 1867, the Piazza was flooded during weekends in August, and from their win-dows, Romans would watch noblemen's car-riages splashing through the water.

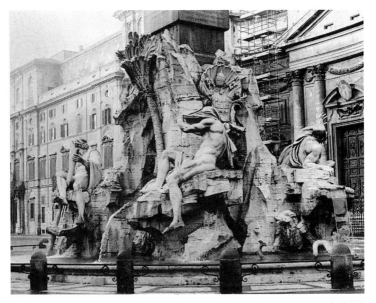

The commission for Bernini's great fountain in the middle of the Piazza was, according to legend, only won by trickery. Pope Innocent X brought the best waters in Rome from the Aqua Vergine and wanted the monument to be surmounted by the Egyptian obelisk which lay in pieces in the Circus of Maxentius on the Appian Way. He invited many artists, but not Bernini (1598–1680), to submit designs, but the sculptor managed to smuggle his model to where it was seen by the Pope and thus secured the work. It was said that the only way of resisting Bernini's designs was not to see his models.

The fountain is a piece of stagecraft; cascading water pours from the island bearing palm tree, rocks and plants, into the four rivers of the world. Each river is personified: the Danube holds up his arms and has a horse nearby; the Ganges has an oar; and the Nile covers his head indicating that the river's source was difficult to find. The Plate is a Negro with a curious armadillo in the basin and he has coins close beside him on the rock representing the riches of the Americas. The travertine stone was not suited to fine effects although it is quicker to carve than marble, and most of the carving was done by assistants although Bernini finished the rock, palm tree, lion and horse, all of which had to be worked on *in situ*. On top of the obelisk is the Pamphilj dove, an appropriate symbol for a Church then expanding over the four continents.

Laid out 1723–26

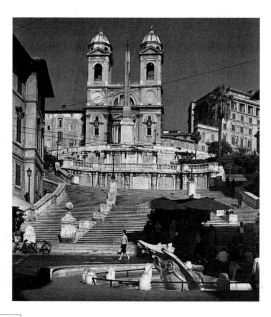

Address
Piazza di Spagna, Roma

Map reference
㉙

How to get there
To Piazza di Spagna:
Metro A. Bus 119.
To Piazza San Silvestro:
buses 52, 53, 58, 58b, 61,
62, 71, 81, 85, 90, 90b, 160.

One hundred and thirty steps lead up from the Piazza di Spagna to the church of Trinità dei Monte and the Pincio. They are most beautiful in spring when there are not only the permanent flower sellers at the bottom but also huge pots of azaleas lining the steps. At all times of the year, just before sunset, they become one of the liveliest spots in Rome. The Piazza has long been the gathering place of artists and writers, especially the British. On the right is the Keats and Shelley Memorial House (page 47) and on the left is Babington's, a well known tea room opened by Miss Babington in the 1890s. Also at the bottom of the steps is a fountain in the shape of a gently leaking boat, cleverly designed by Pietro Bernini, father of the more famous son, to cope with the low water pressure at this point. Since 1622 the Spanish Embassy, which gave its name to the steps and the piazza, has resided in the narrow part of the square. Leading straight off from the steps is the Via Condotti, famous for its shops and the Café Greco founded in 1760; its guests included Goethe, Berlioz, Stendhal, Baudelaire and Wagner amongst others.

Built 1653–66

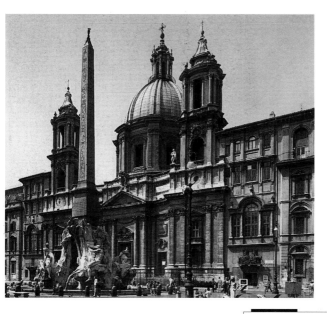

Sant'Agnese is supposed to stand on the site of an ancient brothel into which the thirteen-year-old Christian martyr was thrown because she had spurned the attentions of the son of the Prefect of Rome and refused to make sacrifice to Roman gods. She was led naked through the streets but her hair miraculously grew and covered her, and in the brothel a heavenly light blinded those who tried to look at her. Her suitor was struck dead by a demon when he came to ravish her, and her executioners were burnt by the flames they intended for her; she was finally beheaded in AD 304. The church bears not only the arms of the Pope and Cardinals but also those of the Doria Pamphilj who own it and are responsible for its upkeep. The great facade designed by Borromini (1599–1667) has superimposed orders, with curves pushing out the bases for the towers, and it is crowned with a high cupola. Its complexity and movement is fully High Baroque, and since the effect is to suggest a massive interior, it is a great surprise to find that inside the church is tiny.

Address
Piazza Navona, Roma
✆ 679 44 35

Map reference
(30)

How to get there
To Largo Argentina: buses 44, 46, 56, 60, 62, 64, 65, 70, 75, 81, 87, 90, 90b, 94, 170, 181, 186, 204, 492, 710, 718, 719

Opening times
Mon to Sat 5–6.30; 10–1
Sun and public holidays

SANT'AGNESE FUORI LE MURA

Built mid 4th century, rebuilt mid 7th century

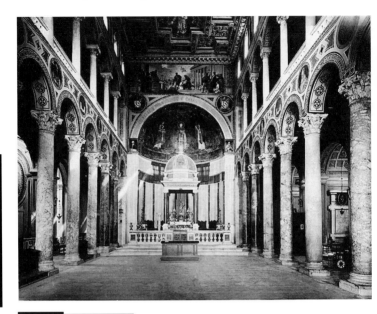

Address
Via Nomentana 349, Roma
© 86.10.840

Map reference
(31)

How to get there
To Via Nomentana: buses
36, 36b, 37, 60, 136, 137,
168, 310, 317

Opening times
For both Sant'Agnese and
Santa Costanza: Daily 7–12
and 4–7.30. Catacombs and
Mausoleum: 9–12 and 4–6.
Closed Sun and Mon
afternoon.

Entrance fee
L 8,000 to catacombs.
Obligatory tour included in
entrance fee.

Sant'Agnese stands over a large cemetery; all early Christian burial grounds were established outside the city walls, far from Roman persecutors. The entrance is beyond the courtyard, down a long flight of steps on the right, and the walls are covered with inscriptions from the catacombs. This church was built over an earlier large basilica that had been constructed over St. Agnes's tomb by Costanza, a daughter or niece of Constantine. She had apparently been suffering from an attack of virulent scrofula but was miraculously cured while praying at the Saint's grave. Fourteen ancient columns separate the nave and aisles, supporting the women's gallery, and in the apse, above the marble episcopal throne, are seventh-century mosaics showing St. Agnes in an elaborate Byzantine court dress, between two restorers of the church, Popes Symmachus and Honorous I. Her tomb can be seen at the end of a guided visit to the catacombs below, starting from a door opposite the flight of steps, but you may have to search for the custodian as he is not always there. He will also unlock the beautiful Mausoleum of Costanza (page 65).

Santa Costanza is unlocked by the custodian of Sant'Agnese (page 64), who also gives a tour of the catacombs underneath the church. The outside is plain and gives little indication of the beauty of the interior. The church is round because it was built as a mausoleum for Costanza, patron of the original basilica of Sant'Agnese, and for her sister Helena, and it is one of the oldest and best preserved Christian buildings in existence. Costanza was buried in a porphyry sarcophagus, now in the Vatican Museum, but there is an eighteenth-century wooden replica in the niche opposite the entrance. It is carved on all sides and therefore probably used to stand in the centre surrounded by the elegant coupled colonnade. The mosaics in the central dome were sadly destroyed in the seventeenth century, but the circular ambulatory has exquisite early fourth-century examples featuring numerous birds and animals, medallions and geometric patterns. Two sections have delightful scenes of a grape harvest with figures stamping around in the wine press and filling wagons drawn by bulls. It is not surprising to find that during the Renaissance the church was thought to be a temple dedicated to Bacchus.

Built 1479–83

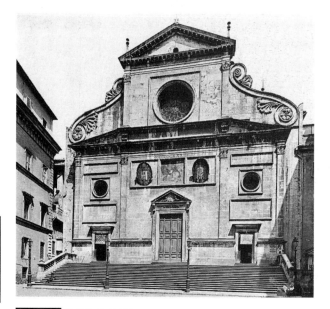

Address
Piazza Sant' Agostino,
Roma.
© 68.80.1962

Map reference
(32)

How to get there
To Largo Argentina: buses
44, 46, 56, 60, 62, 64, 65,
70, 75, 81, 87, 90, 90b, 94,
170, 181, 186, 204, 492, 710,
718, 719

Opening times
Daily 8–12 and 4–7.30

Sant'Agostino was commissioned by Guillaume d'Estouteville, Cardinal-bishop of Ostia (1461–83), as part of a large Augustinian convent. D'Estouteville was the most senior cardinal in the College and one of the most wealthy. He owned the grandest fifteenth-century palace in Rome, now demolished, and built this church from material plundered from the Colosseum and inscribed his name and titles across the frieze of the somewhat plain Renaissance facade. It was a centre of worship for Renaissance Humanists; in 1512 one scholar, Giovanni Goritz, commissioned Raphael to paint a fresco of the Prophet Isaiah which can be seen on the third pillar on the left, and asked Sansovino to paint a *Madonna and Child with St. Anne* beneath it for his funerary monument – this has since been moved. The high altar by Bernini has a Byzantine Madonna brought back from Constantinople. The interior was redecorated by Vanvitelli in the 1750s and the first chapel on the left contains *The Madonna of the Pilgrims* by Caravaggio.

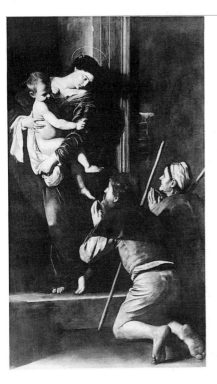

The *Madonna of the Pilgrims*, also known as the *Madonna of Loreto*, by Caravaggio (1573–1610) hangs in the first chapel on the left of Sant'Agostino. The artist was commissioned by the heirs of Ermete Cavalletti who left five hundred scudi for a chapel to be decorated with a 'Madonna of Loreto', which specifically refers to a statue from that town. Near the Adriatic coast, Loreto was one of the great places of pilgrimage because according to legend the house where the Virgin Mary was born was miraculously transported there from the Holy Land after its conquest by the Moslems.

In the shallow chapel, we are invited to join the two peasants kneeling in adoration and share their vision of the statue come to life. Like the Virgin and Child, the old woman and the younger man may also be mother and son, and although they are poor, they receive Her blessing as a reward for their faith. Their staffs and his dirty feet must have recalled the pilgrims of Holy Year of 1600 when over a million visited Rome. The beautiful Mediterranean features of the Virgin have been identified as those of Caravaggio's friend, Lena, who became the cause of a dispute in the summer of 1605. She was apparently poor but honourable and was admired by a notary; he was furious that she went to the studio of the villanous painter and for his slander, the hot-headed Caravaggio attacked him in the Piazza Navona, hitting him on the head with a sword.

Built 1658–78

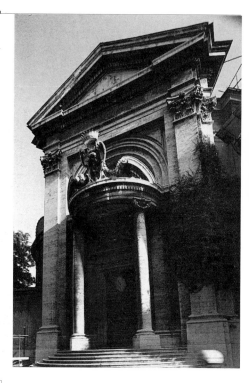

Address
Via del Quirinale 29, Roma
© 47.44.801

Map reference
(33)

How to get there
To Via Nazionale: buses 57,
64, 65, 70, 75, 170

Opening times
Wed to Mon 9–12 and 4–7.
Closed in August

Entrance fee
Donations expected if St.
Stanislas's rooms are
shown

This little church was commissioned by Cardinal Camillo Pamphilj, nephew of Pope Innocent X, for Jesuit novices at the Quirinale. It is an example of how the splendour of the Baroque need not be on a large scale. The design by Bernini (1598–1680) is full of graceful curvilinear movement; the facade with its semi-circular portico on a flight of steps projects outwards like the low screen wall on either side, mirroring the oval shape of the church. Inside, it is a surprise to find the long axis of the church is at right angles to the entrance, so the altar seems unusually close. Set behind two pairs of fluted columns, the altarpiece by Guillaume Courtois is of the *Martyrdom of St. Andrew* and above, in the broken pediment, the sculpted figure of the saint by Antonio Raggi floats up on a cloud to angels and cherubim in the dome and to the dove of the Holy Spirit in the lantern. Given only a small site on which to build, Bernini created a light interior enriched with sculpture and coloured marble.

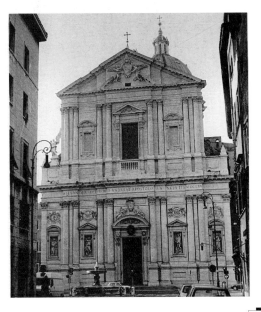

The brilliant, newly cleaned, white facade of Sant' Andrea della Valle, designed by Carlo Rainaldi, stands out on Corso Vittorio Emanuele, the road which was made after Unification in Italy in 1870, cutting through tiny medieval streets to give easy access to St. Peters. The area was known as the valley, which is how the church acquired its name. In Classical times Agrippa turned the low-lying marshy land into an artificial lake as part of the gardens of his baths nearby. The church was begun by Fra Francesco Grimaldi and its aisleless nave, high barrel-vault and large apse recall the Gesù (page 45). Carlo Maderno added the dome, the second highest in Rome after St. Peter's. High up, at the end of the nave are fifteenth- and early sixteenth-century monuments of the two Piccolomini Popes, Pius II and Pius III. Domenichino (1581–1641) decorated the apse with scenes from the life of St. Andrew and the pendentives of the dome with the Evangelists, but the dome itself, showing *The Glory of Paradise*, was painted by Lanfranco (1582–1647). However, the church is probably best known for being the setting for the first act of *Tosca*.

Address
Piazza Sant'Andrea della
Valle, Roma
✆ 68.61.339

Map reference
㉞

How to get there
To Largo Argentina: buses
44, 46, 56, 60, 62, 64, 65,
70, 75, 81, 87, 90, 90b, 94,
170, 181, 186, 204, 492, 710,
718, 719

Opening times
Daily 7.30–12 and
4.30–7.30

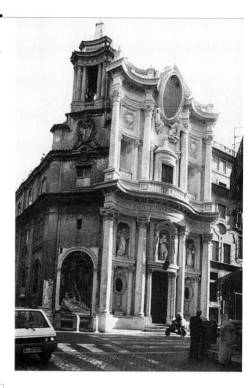

Address

Via del Quirinale 23, Roma

℗ 488 32 61

Map reference

㉟

How to get there

To Piazza Barberini:Metro A.
Buses 52, 53, 56, 58, 58b,
60, 61, 62, 95, 116, 119, 204,
492

Opening times

Mon to Sat 9–12.30 and
4–6; Sun 11–11.30

This church is named after the four fountains at each angle of the crossroads where it is situated. On the tall thin facade Borromini (1599–1667) has applied half columns to a gently curving surface and these convex/concave rhythms continue on the towers and lantern. This highly imaginative effect defies the cramped site on a narrow street. Sometimes known as San Carlino because of its tiny size, the church is dedicated to San Carlo Borromeo, an ardent reformer of the Counter-Reformation, and is part of the Spanish Trinitarian monastery. The church and sober cloisters were Borromini's first independent commission and occupied him all his working life. The interior reveals his delight in geometry; the plan is essentially diamond-shaped but the walls curve gently and meet an oval dome where the octagons, crosses and hexagons of the coffering get smaller towards the lantern to heighten its appearance. The Procurator General of the Trinitarian Order claimed that 'in the opinion of everybody nothing similar with regard to artistic merit, caprice, excellence and singularity can be found anywhere in the world'.

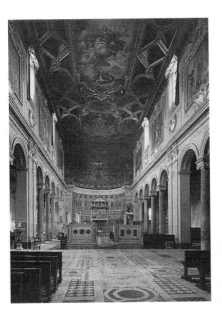

A visit to the church dedicted to the fourth Pope, Clement I (AD 90–99), allows you to travel back in time. At street level is the church, built after the destruction by the Normans, with a tranquil forecourt and a beautiful cosmatesque floor. The mosaics in the apse show animals and birds drinking from the life-giving waters which flow from the foot of the cross. The choir dates from the sixth century and above the nave is a heavily carved Baroque ceiling. To the right of the entrance is a chapel which Masolino da Panicale (1383–1447) decorated with *The Lives of St. Catherine of Alexandria and St. Ambrose*. Opposite the entrance is the entrance to the excavations which began in 1857, revealing the narthex, nave and side aisles of the earlier church; glimpses of columns, frescoes and fragments can be seen between the walls supporting the church above. In the left aisle is a recess in the floor which may be a large baptismal font. Beyond this is a fourth-century staircase which goes down a further level to a temple of Mithras, the Persian god of light, and a first-century house through which water runs to the Cloaca Maxima.

Address

Piazza San Clemente, Roma (entrance through side door in Via di San Giovanni in Laterano)

✆ 70 45 10 18

Map reference

㊱

How to get there

To Colosseo: Metro B.
Buses 11. 15, 27, 30b, 81, 85, 87, 118, 186, 204, 673.
Tram: 13, 30b.

Opening times

Daily 9–12.30 and 3.30–6.30 (October to March open until 6)

Entrance fee

L 2,000 to excavations

SAN GIOVANNI IN LATERANO

Begun AD 313–22, renovated 1646–1650

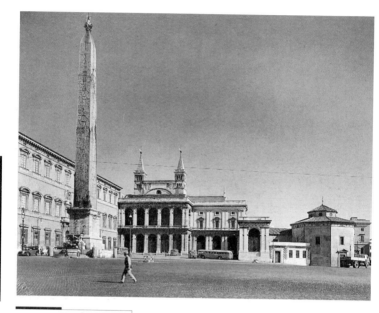

Address
Piazza di San Giovanni in
Laterano 4, Roma
✆ 69.88.6452/6433

Map reference
㊲

How to get there
To San Giovanni Laterano:
Metro A. Buses 4,15,16, 81,
85, 87, 118, 186, 218, 613,
650, 714, 715. Tram: 13,
30b.

Opening times
Daily 7am-7pm (Oct to
March 7–6)

Entrance fee
Baptistry and Museum
currently closed for
restoration
L 4,000 for Cloister

San Giovanni in Laterano is the Cathedral of Rome, founded by Constantine in AD 312, and it was the seat of the Popes until the mid fifteenth century. Sadly, little remains of the magnificence of the original basilica because the interior was remodelled by Borromini (1599–1667) for the Jubilee year of 1650 and a monumental facade and ceiling were added in the eighteenth century. Inside, Borromini coupled its ancient columns and set them in huge piers. Statues of the Apostles were added in the eighteenth century. Amongst its many decorations, San Giovanni has the bronze doors from the Senate House in the Forum, an ancient statue of Constantine from Baths of Diocletian, a cosmatesque floor probably from the fifteenth century, a Gothic baldacchino of c. 1370 covering the reliquary with the heads of Saints Peter and Paul, and mosaics in the apse of 1288–94 which have been heavily restored. Also of interest are the Romanesque cloister of 1215–32 by the Cosmati, cluttered with fragments of sculpture, the Baptistry built by Constantine, and the Scala Santa, which apparently houses the stairs Christ climbed in Pontius Pilate's palace.

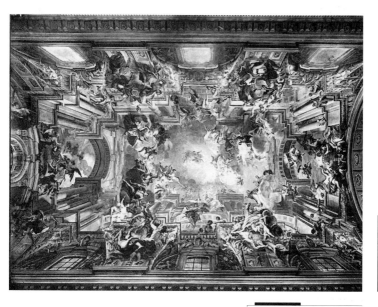

This is Rome's second church of the Jesuit Order and is dedicated to its founder, St. Ignatius Loyola. Its design, executed by the Jesuit mathematician Orazio Grassi (1583–1654), follows that of the Gesù (page 45) and rivals it in the sumptuousness of the decoration. The frescoes in the vault of *c.* 1685 by Andrea Pozzo (1642–1709) have astounding illusionistic effects; the vault shows the missionary work of the Jesuits set into architectural trompe l'oeil and the *Entry of St. Ignatius into Heaven* soaring high above. The best place to see it is from the spot marked on the floor halfway down the nave, and this is also the best place to notice how the dome too is an illusion. It was never built because of the lack of funds, so Pozzo created the effect of a dome over the crossing on a canvas seventeen metres in diameter.

Sant'Ignazio is the church of the Collegio Romano which surrounds it, where eight future popes studied. Its massive facade proclaims authority, but it now stands rather incongruously in an elegant Rococo piazza designed by Filippo Raguzzini in 1727.

Address
Piazza di Sant'Ignazio, Roma
℡ 679 44 06

Map reference
㊳

How to get there
To Piazza Venezia: buses 44, 46, 56, 57, 60, 62, 64, 65, 70, 75, 81, 85, 87, 90, 90b, 95, 160, 170, 181, 186, 204, 492, 710, 718, 719

Opening times
Daily 8–12.30 and 4–7.15

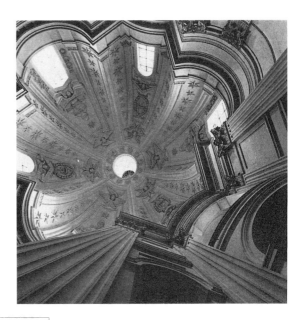

⭐ SANT'IVO ALLA SAPIENZA

Built 1642–60

Address
Corso del Rinascimento 40,
Roma

Map reference
㊴

How to get there
To Largo Argentina: buses
44, 46, 56, 60, 62, 64, 65,
70, 75, 81, 87, 90, 90b, 94,
170, 181, 186, 204, 492, 710,
718, 719

Opening times
Sunday Mass 10–12. Closed
July and August

The Sapienza was begun in 1303 as a law school
and was the University of Rome until 1935. The
Barberini pope, Urban VIII, admired Borromini's
work at San Carlo alle Quattro Fontane (page
70) and employed him to design the courtyard of
the Sapienza, its library and a church dedicated
to Sant'Ivo, or St. Yves, a Breton priest and
lawyer. The courtyard is entered through
Giacomo della Porta's Renaissance facade and
the articulation of the open arcade continues
onto the curved facade of the church at the far
end. An idea of its complex interior floor plan can
be gained from the curving walls of the high
drum. It is essentially a six pointed star with
three points turned to form concave apses with
convex walls between. The spiral lantern above,
which can be seen from many sites in Rome, is
highly imaginative and found many imitators,
especially in Germany. Inside, Borromini
(1599–1667) planned plain white walls with high-
lights of gold, rejecting the contemporary taste
for polychrome marble. The spatial subtleties are
far from traditional notions of the Roman
Baroque.

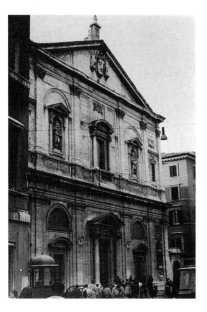

San Luigi dei Francesi was built partly from funds dedicated by Cardinal Giullaume d'Estouteville. This wealthy patron was related to the French royal family, and San Luigi became the French national church in Rome. The late Renaissance facade with two levels of orders is attributed to Giacomo della Porta (1539–1641) and 'a certain master Gian, a Frenchman' carved the statues and a medallion containing a salamander, an emblem of the French royal house. In 1764 the French artist, Antonio Derizet, richly decorated the interior with marble and gilded stucco and painted the vault with *The Death and Glory of St. Louis*. The second chapel on right has frescoes *c.*1616 by Domenichino (1581–1641) of *The Life of St. Cecilia*. On the right she gives clothes to the poor and on the left she refuses to make pagan sacrifices. In 1597 Caravaggio received his first commission for the large-scale religious works in the Contarelli Chapel, the fifth on the left, which are undoubtedly the church's most prized artistic possession.

Address
Piazza San Luigi dei
Francesi, Roma
✆ 68.82.271

Map reference
⓵⓪

How to get there
To Largo Argentina: buses
44, 46, 56, 60, 62, 64, 65,
70, 75, 81, 87, 90, 90b, 94,
170, 181, 186, 204, 492, 710,
718, 719

Opening times
Daily 8–12.30 and 3.30–7.
Closed Thur afternoon

1599–1600

Caravaggio (Michelangelo Merisi)

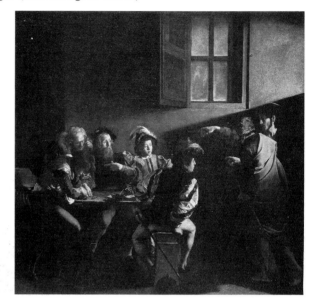

SAN LUIGI DEI FRANCESE

The fifth chapel on the left of San Luigi dei Francesi has three canvases which were Caravaggio's (1571–1610) largest works to date and his first public commission. The canvas on the left (shown above) illustrates the Gospel passage: 'Jesus saw a man called Matthew at his seat in the custom-house, and said to him, "Follow me", and Matthew rose and followed him.' A shaft of light falls on the saint, who gestures to confirm his calling as he sits with his companions around a table as if about to play cards. The two on the left are so engrossed in sinfully counting money that they are oblivious to the presence of Christ. Their contemporary costumes represent their wordly concerns. On the right St. Peter and Christ, whose feet are turned as if already leaving, are bare-foot and wearing ancient robes. The two halves of the composition are linked by Christ's limp hand which recalls the hand of God Creating the Sun, Moon and Planets in Michelangelo's Sistine Ceiling (page 110).

On the other side of the chapel is the dramatic *Martyrdom of St. Matthew*. The saint was condemned to death because he disapproved of the King of Ethiopia's demand for a virgin. The composition concentrates on the executioner in the centre seizing the wounded helpless martyr. The altar-piece of *St. Matthew and the Angel* was the second version Caravaggio painted for the Chapel; the first was refused because the church thought his interpretation lacked dignity. Caravaggio's works were, and still are, frequently controversial.

Begun c. 590, extended 13th century

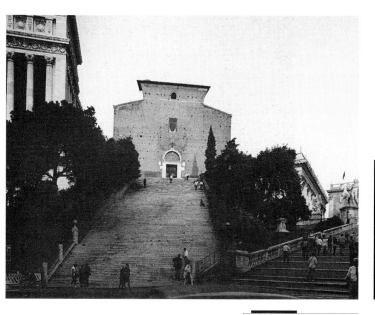

One hundred and twenty-four marble steps, laid out in the fourteenth century as thanksgiving for the end of the Black Death, lead up to Santa Maria in Aracoeli. Legend states that this was the site where, before the Nativity, the Tiburtine Sibyl told Augustus that a Son of God would be born, hence Ara Coeli, meaning The Altar of Heaven. The church was built with columns taken from a variety of ancient buildings and their shafts, capitals and bases are all different shapes and sizes. The Franciscans adopted the church adding Gothic windows and vaults and the fine cosmatesque floor littered with tombs. The first chapel on the left is the Bufalini chapel with *Scenes from the Life of San Bernadino of Siena* by Pinturicchio (1454–1513) and the heavily carved and gilded Baroque ceiling commemorates the Victory of Lepanto in 1571. It was in this church that in 1764 Gibbon decided to write his *Decline and Fall of the Roman Empire*.

Address
Piazza d'Aracoeli, Roma
✆ 679 81 55

Map reference
㊹

How to get there
To the Piazza Venezia:
buses 44, 46, 56, 57, 60, 62, 64, 65, 70, 75, 81, 85, 87, 90, 90b, 95, 160, 170, 181, 186, 204, 492

Opening times
Daily 7–12 and 3.30–5.30.
(March to October daily 7–12 and 3.30–7)

SANTA MARIA IN COSMEDIN

Begun 6th century

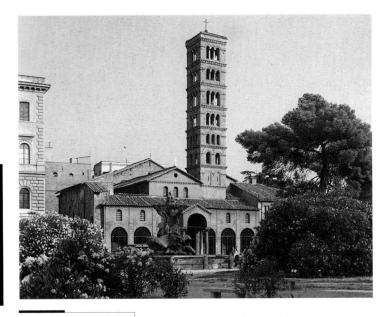

Address
Piazza della Bocca della
Verità 18, Roma
✆ 678 14 19

Map reference
㊷

How to get there
To Piazza Bocca della
Verità: buses 15, 23, 57, 90,
90b, 94, 95, 116, 160, 204,
713, 716

Opening times
Daily 9–1 and 3–6. (October
to March daily 9–1 and 3–5)

From the outside, this church appears medieval with its twelfth-century portico and seven-storeyed campanile. The interior, however, combines two earlier buildings; eleven gigantic columns from the Imperial market inspector's office sunk into the wall on the left, and part of an early Christian welfare centre. This area close to the river was the Roman cattle market and there were grain stores where corn was distributed to the poor. Either side of the door inside, the two black stones set into the wall were Roman standard weights. In the eighth century the church was rebuilt for the Greeks who had fled from iconoclastic persecutions. In the twelfth century the choir, candelabrum, episcopal throne and pavement were decorated by the Cosmati – Greek craftsmen who worked in small pieces of stone – and the gallery was also walled in at this time. Above the altar is a fourteenth-century canopy and underneath is the skull of St. Valentine. Back outside in the portico is the Bocca della Verità, or the 'mouth of truth'; a Classical relief of a face which according to legend would snap off the fingers of any liar who inserted his or her hand into the mouth.

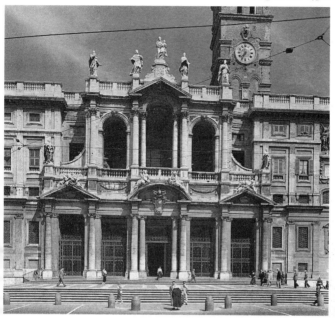

On an August night in AD 352 the Virgin apparently appeared to the Pope and told him to build a church on the Esquiline covering the area of the patch of snow he would find there the following morning. This church, however, was completed some hundred years later to honour the Virgin, who had been given a new dignity as the Mother of God at the Council of Ephesus AD 431. The Baroque facade by Ferdinando Fuga (1699–1781) conceals the ancient church in which something of the magnificence of the original interior has been preserved. There are noble Ionic columns of Athenian marble, fifth-century Old Testament mosaics above the architrave in the nave and scenes from the Life of Christ over the arch. The high altar has the relics of St. Matthias and pieces of wood believed to be Christ's manger. To the left and right of the altar are the Baroque Pauline Chapel of 1611 built for Paul V, and the Sistine Chapel of 1585 built for Pius V and Sixtus V respectively. The ceiling of the nave of *c.* 1500 is said to have been gilded with the first gold brought back from America.

Address
Piazza di Santa Maria Maggiore, Roma
✆ 48 31 95

Map reference
⑧

How to get there
To Termini: Metro A & B. To Piazza dell'Esquilino: buses 4, 9, 16, 27, 70, 71, 204, 613, 714, 715

Opening times
Daily 7am–8pm (October to March 7am–7pm)

SANTA MARIA DELLA PACE

Built c. 1480–84

Address
Vicolo del Arco della Pace 5,
Roma
℡ 686 11 56

Map reference
㊹

How to get there
To Largo Argentina: buses
44, 46, 56, 60, 62, 64, 65,
70, 75, 81, 87, 90, 90b, 94,
170, 181, 186, 492, 710, 718,
719

Opening times
Tue to Sat 10–12 and 4–6.
Sun 9–11am

Santa Maria della Pace has a pretty semicircular portico designed by Pietro da Cortona (1596–1669), which was added to the church in 1656. The entrance, however, is usually from a side door to the left of the portico. This leads into the cloister, designed by Bramante (1444–1514) in around 1502; this was probably his first commission in Rome. Inspired by the monuments of ancient Rome, the arches spring directly from the piers but Bramante curiously placed a column directly above the centre of each arch.

A legend claimed that a painting of the Virgin in the old porch bled when pierced by a sword, and when Sixtus IV came to see the miraculous image he vowed to build a church in thanksgiving when peace was restored between Rome and Florence. The church has a domed octagon and rather short nave, presumably due to the shape of the site. Above the first chapel on the right are Raphael's frescoes of four Sibyls to whom angels are prophesying, commissioned by Agostino Chigi. On the octagon to the right of the high altar is *The Presentation in the Temple* by Baldassare Peruzzi.

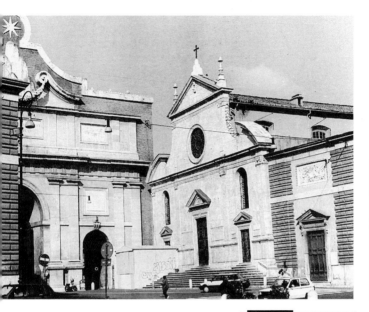

The present church of Santa Maria del Popolo was built by the della Rovere Pope, Sixtus IV. Originally it stood with its monastery amongst vineyards and vegetable plots, and it held an important position as the first church to be seen by visitors from the north entering Rome through the Porta del Popolo. It became a popular site for funeral monuments, most notably those of members of the Pope's family whom he had appointed as Cardinals and the oak, the emblem of the della Rovere, is conspicuous throughout. The Pope encouraged his Cardinals to decorate the interior, and several chapels were painted by the fashionable Pinturicchio (*c.* 1454–1513), who was also responsible for the frescoes high up in the apse: *The Coronation of the Virgin, Evangelists, Sibyls* and *The Four Fathers of the Church*. The apse was extended *c.* 1502 by Bramante (1444–1514) as one of his earliest works for Julius II. The Chigi Chapel designed by Raphael (page 82) is the second on the left and, to the left of the sanctuary, a tiny chapel has two magnificent Caravaggios (page 83).

Address

Piazza del Popolo 12, Roma

✆ 361 08 36

Map reference

㊺

How to get there

To Flaminio: Metro A. To Piazza del Popolo: buses 90, 90b, 95, 119, 204, 490, 495, 926. Tram 225

Opening times

Daily 7–12 and 4–7 (October to March 7–12 and 4–6)

The Chigi Chapel

1513–16

Raphael (Raffaello Sanzio)

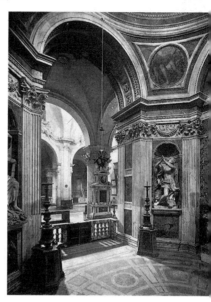

Agostino Chigi, patron of the Villa Farnesina, asked Raphael (1483–1520) to design this funeral chapel for him and his brother, Sigismondo. Raphael had become architectural consultant to St. Peter's in 1512, and as he drew up his report for Leo X on the state of ancient Rome he came to realize that many of the existing ruins represented merely the structure of buildings which had, in antiquity, been richly covered in ornament and marble. The design of The Chigi Chapel reflects these discoveries since every surface is highly decorated. Raphael devised a deeply carved frieze between the Corinthian capitals, the mosaics in the dome, frescoes, and sculptures in the niches. The altarpiece of *The Birth of the Virgin* is by Sebastiano del Piombo (1485–1547), and dates from 1530–34. The tombs follow Raphael's designs inspired by the Pyramid of Caius Cestius. Work on the Chapel stopped when both Agostino Chigi and Raphael died in 1520, but it stands as a landmark in art history because the artist unified all the arts in one design. The chapel was finally completed by Bernini in the 1650s for the future Chigi Pope, Alexander VII.

The Conversion of St. Paul

1600–01

Caravaggio
(Michelangelo Merisi)

When the immensely rich Tiberio Cerasi acquired the chapel at Santa Maria del Popolo he immediately commissioned Annibale Carracci to paint the altarpiece of the *Assumption of the Virgin* and to design the frescoes for the vault. Shortly afterwards Caravaggio (1573–1610) was contracted to paint the two canvases on the side walls. St. Paul was known as Saul, a Christian persecuter, until his conversion on the road to Damascus. He was thrown to the ground, a great light blinded him and he was told that he was destined to take the faith to the Gentiles. Caravaggio concentrates the drama with strong contrasts of light and shade and by enlarging the figures so they seem to extend out of the frame. Saul lies in the foreground in sharp foreshortening with his hands raised as if in ecstasy while the larger part of the composition is taken up by the farm horse.

Crucifixion of St. Peter

1600–01

Caravaggio
(Michelangelo Merisi)

As Saul willingly receives the grace of God in his conversion (above), St. Peter accepts his crucifixion with calm resolution. Inspired by Michelangelo, Caravaggio (1573–1610) shows him already nailed to the cross. The clumsy executioners push and strain to raise him upsidedown at his own suggestion, so that his martyrdom should not be compared to Christ's. Being raised allows the saint to look out of the painting towards the altar which enshrines the faith that sustained him through the ordeal. In both of the paintings in the chapel the compositions are based on strong diagonals. This is probably because Caravaggio realized that a contemporary visitor would only be allowed to see the paintings from outside the chapel, so they needed to be powerful and dramatic.

SANTA MARIA SOPRA MINERVA

Built 1280

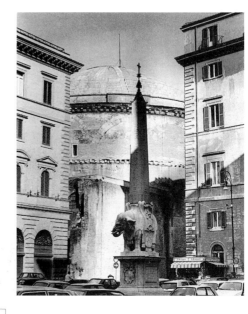

Address
Piazza della Minerva 42,
Roma
✆ 67 93 926

Map reference
㊻

How to get there
To Largo Argentina: buses
44, 46, 56, 60, 62, 64, 65,
70, 75, 81, 87, 90, 90b, 94,
170, 181, 186, 204, 492, 710,
718, 719

Opening times
Daily 7–1 and 4–7

In front of Santa Maria sopra Minerva stands a seventh-century BC obelisk supported by Bernini's endearing little elephant, which was unveiled in 1667. The first church was built here before 800 in the ruins of a temple of Minerva, hence its name. The plain fifteenth-century facade has plaques marking the height of Tiber floods and it disguises the only Gothic church in Rome. The little building was erected in the thirteenth century while the Papacy was in Avignon, and was rebuilt with an adjoining monastery by the Dominicans in 1280 because their headquarters at Santa Sabina were too remote. There are numerous chapels and monuments commissioned by great Roman families. The church also has strong Florentine associations: the Carafa Chapel has frescoes by Filippino Lippi (1457–1504); by the choir is *The Risen Christ* by Michelangelo (1475–1564) which is perhaps not the success expected of the artist; Fra Angelico (1400–55) is buried here; and behind the altar are monuments to the Medici Popes, Leo X and Clement VII. Under the high altar lies St. Catherine of Siena. In the monastery is the room where Galileo was tried.

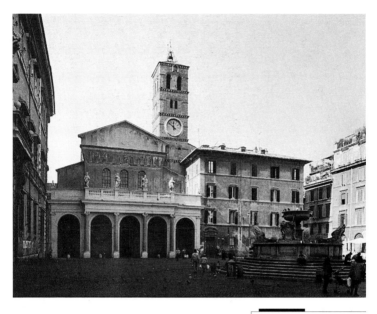

Santa Maria in Trastevere was built on the site of a veterans' hospice and an early Christian meeting place, and rebuilt in the twelfth century almost as we see it today, with a Romanesque campanile and a mosaic of the Madonna and ten female figures on the facade. It may have been the first church in Rome to be dedicated to the Virgin. The portico was added by Carlo Fontana in 1702 and houses some inscriptions from the catacombs and damaged frescoes. Inside huge ancient columns from various Roman buildings form the nave, and there are fine twelfth-century mosaics on the arch. The apse has a mosaic of *The Virgin Enthroned with Christ with Popes and Martyrs*, which may be the earliest example of this subject. Below this are six mosaics of *The Life of the Virgin c.* 1290 by Pietro Cavallini (1250–1330). Near the choir and paschal candlestick is the spot where a fountain of oil apparently flowed for one day at the time of Christ's birth. This church is in the heart of Trastevere, in a beautiful piazza with a seventeenth-century fountain, which is an ideal spot for sitting in a café and watching Roman life.

Address

Piazza di Santa Maria in Trastevere, Roma

© 581 48 02

Map reference

(47)

How to get there

To Trastevere: buses 23, 44, 56, 60, 75, 170, 181, 280, 710, 718, 719, 774, 780

Opening times

Daily 7.30–1 and 4–7

Built 1605–20

Address
Via XX Septembre 17, Roma
✆ 482 61 90

Map reference
(48)

How to get there
To Piazza della Republica:
Metro A. Buses 37, 60, 61,
62, 136, 137, 492, 910

Opening times
Daily 6.30–12 and
4.30–6.30

The church was begun for Paul V by the Carmelite friars, and was initially known as St. Paul's but was renamed when it received an image of the so-called 'Madonna of Victory'. This had been found unharmed in the ruins of the Castle of Prague by the victorious Catholic forces after the defeat of the Protestant army of Frederick of Bohemia at the Battle of the White Mountain in 1620. It was burnt in 1833 but a copy replaces the original, set above the altar amid clouds and gilded rays. The facade of the church was paid for by Cardinal Scipio Borghese in exchange for a statue of a Hermaphrodite, now in the Louvre, found in the garden of the monastery. The interior has rich Baroque decoration; the stucco work is by Mattia de Rossi, a pupil of Bernini's, with angels appearing to support the cornice, vault and choir gallery. However, the church is most famous for Bernini's *Ecstasy of St Teresa* in the Cornaro Chapel.

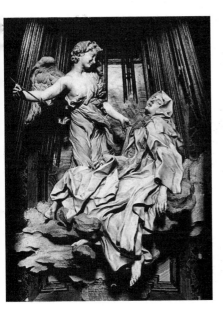

SANTA MARIA DELLA VITTORIA

Cardinal Federigo Cornaro, Patriarch of Venice, commissioned Bernini (1598–1680) to design his funeral chapel in the shallow transept of the Carmelite church. He began with the architectural framework which houses the main altarpiece. To the left and right, the walls are designed like illusionistic theatre boxes in which sculptures of prominent members of the Cornaro family sit in lively poses. Bernini has combined many different materials in a tiny space to create a grand impression; richly coloured marble frames the white *Ecstasy of St. Teresa* and gilded bronze shafts reflect light from a natural source above.

St. Teresa of Avila was a Spanish Carmelite reformer who described a mystical experience in which she was visited by an angel. She wrote that 'in his hands I saw a great golden spear, and at the iron tip there appeared to be a point of fire. This he plunged into my heart several times so that it penetrated to my entrails. When he pulled it out, I felt that he took them with it, and left me utterly consumed by the great love of God'. Bernini was a devout Catholic and he intended to translate her vision as she had written it into stone. His sculpture shows the actual moment of ecstasy. Wafting in on a cloud the angel pierces her heart and smiles sweetly at the saint, whose body falls limply backwards while her drapery ripples in response to the pleasure of divine rapture.

⭐ SAINT PETER'S

Built 1506–c. 1667

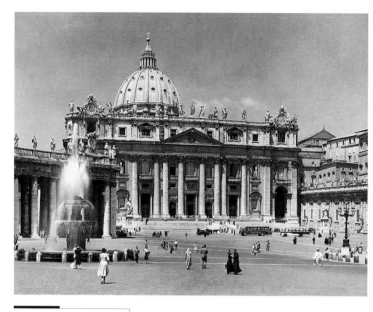

Address
Piazza San Pietro, Roma
✆ 698 44 66 or 698 48 66

Map reference
㊾

How to get there
To Piazza San Pietro: bus
64. To Piazza Risorgimento:
bus 23, 32, 49, 51, 81, 492,
907, 990, 991. Tram 19. To
Ottaviano: Metro A

Opening times
Basilica: summer daily 7–7;
winter 7–6. Dome: summer
daily 8–5; winter 9–4.45.
Treasury: summer daily 8–6;
winter 9–5

Entrance fee
Dome: L 6,000 with lift;
L 5,000 on foot. Treasury:
L 3,000.

St. Peter's covers the grave of the Apostle who was crucified nearby, outside the old city walls. The first basilica was built by Constantine in the fourth century AD, but by the fifteenth century it was in a dilapidated state. In 1506 Julius II tore down the old basilica and laid new foundations. Bramante's (1444–1514) design, inspired by Classical examples, was on a scale that was intended to surpass the buildings of antiquity and proclaim the Pope's authority as the head of the Church. Carlo Maderno's facade of 1607–14 is more like that of a palace than a church, but Michelangelo's dome leads the eye up through the coupled columns of the deep drum past the ribs to the lantern; a majestic crown for the Basilica of the principal Apostle of Christ. Bernini's oval piazza of 1656–67 is designed to hold thousands of pilgrims in two semicircular Doric colonnades. The enclosure was somewhat ruined in 1937 when the colonnade which linked the two arms was destroyed to create the wide approach of the Via della Conciliazione. The obelisk in the centre used to stand in the Circus of Caligula and took nine hundred men to erect.

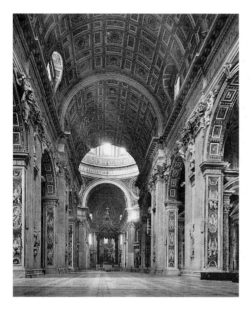

The successive architects of St. Peters were undecided about the plan of the basilica. A centralized building would have emphasized the Apostle's tomb, but the longitudinal plan, more suitable for processions, eventually succeeded. As if a boast was necessary, along the floor of the immense nave the names of other great churches of the world are given with an indication of their lengths, which seem diminutive in comparison. The sumptous Baroque decoration by Bernini (1598–1680) focuses on the tomb of St. Peter directly under the dome with a massive bronze baldacchino with Solomonic columns, covered with bees, the emblem of the Barberini Pope, Urban VIII. Surrounding it are the four massive piers, with statues in niches, devoted to important relics: the head of St. Andrew, the handkerchief of St. Veronica, a piece of the Cross brought by St. Helena and the lance of St. Longinus which pierced Christ at the Crucifixion. At the east end, a glorious sculptural surround houses the wooden chair belonging to St. Peter; the four Doctors of the Church are shown beneath. There are magnificent views from the top of the lantern and, halfway up inside, you can look down on the interior of the church to gain a good idea of its staggering scale.

1499

Michelangelo Buonarroti

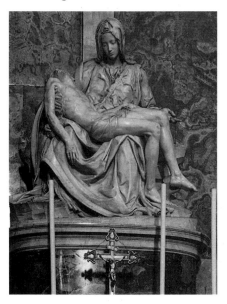

This profoundly moving sculpture was executed by Michelangelo (1475–1564) when he was only twenty-four. It was commissioned by the French Cardinal to the Holy See, Jean de Villiers de la Groslay, for his funerary monument in his chapel in Old St. Peter's. Jacopo Galli, a Roman banker, collector and early patron of the artist, acted as guarantor and rightly promised that the Pietà would be 'the most beautiful work of marble in Rome, one that no living artist could better.'

The Cardinal chose an appropriate subject for his tomb; the Virgin mourning her son after the Crucifixion while holding Him in her arms as she did when He was an infant. This had traditionally been a theme much favoured by northern artists. Michelangelo's problem was how to harmoniously place Christ in the lap of His mother and he solved it by disguising their dissimilar proportions by the Virgin's massive bulk of drapery which supports Him. Her gentle face is not that of a mother with a fully grown son, but of a youthful Virgin whose beauty is a reflection of purity of her soul, and the gesture of her open hand invites us to join her grief. This highly finished and polished sculpture is the only work Michelangelo signed, across the band of her chest, apparently because he overheard people mistaking its creator. The Pietà is sadly dwarfed by the architecture and is now placed behind glass following an incident in 1972 when a lunatic smashed the Virgin's face.

Built 442, restored 1475–1500

The original church of San Pietro in Vincoli was founded in AD 442 by Pope Sixtus III as a shrine for the chains of St. Peter. Some legends claim that these fettered the saint in Jerusalem, others that they were from his incarceration in the Mamertime prison in Rome (page 48). Another theory is that they are both sets of chains, donated at different times, which miraculously united when they were brought together. They are now preserved beneath the high altar. The church was restored in 1475 under Sixtus IV by Meo del Caprina who designed the facade, and again in c. 1500 by his nephew Cardinal Giuliano della Rovere, later Julius II. Nearby was the Cardinal's palace with gardens containing his famous collection of Classical sculpture, which he transferred to the Vatican on his election to the Papacy. The church still has its basilican form with twenty ancient Doric columns dividing the wide nave from the aisles. The ceiling of the nave was painted by G.B. Parodi and illustrates the miraculous healing power of St. Peter's chains. Most people come to see the tomb of Julius II containing Michelangelo's famous sculpture of *Moses*.

Address
Piazza di San Pietro in Vincoli 4A, Roma
✆ 488 28 65

Map reference
(50)

How to get there
To Colosseo: Metro B. Buses 11. 15, 27, 81, 85, 87, 186, 204. Trams 13, 30b.

Opening times
Summer: Mon to Sat 7–12.30 and 3.30–7. Winter: Mon to Sat 7–12 and 3.30–6. Sun 8.45–11.45

Moses

1513–16

Michelangelo
Buonarroti

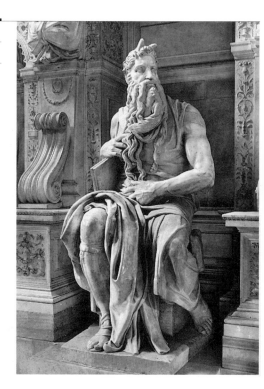

The tomb of Pope Julius II, now in San Pietro in Vincoli, is a poor shadow of the original project. Initially the Pope wanted his funerary monument to stand in the new basilica of St. Peter's as a massive, free-standing, architectural structure, like a pyramid, housing forty over life-size statues with relief panels between. Michelangelo (1475–1564) spent three years making plans and overseeing the quarrying of marble, but the Pope halted the project and commanded the artist to decorate the Sistine Chapel ceiling. Once this was completed, Michelangelo returned to the tomb to carve the Moses, but the death of the Pope in 1513 began a history of struggles between the executors of Julius's will and successive popes who insisted Michelangelo work for them. The tomb was finally erected in 1545, considerably reduced in size, no longer free-standing, and not in the new St. Peter's but in the church where Julius had been Cardinal.

Moses, like a stone version of the Prophets on the Sistine Ceiling, carries the blocks on which God wrote the Ten Commandments. His rippling beard and massive form, with his leg thrust back and head abruptly turned, convey energy and anger as if he knows mankind will disobey God's words. With this tomb, Julius likens himself to God's law-giver on earth. The curious lumps on Moses's head have been explained as coming from a mistranslation of the Bible where his head is said to have become 'horned' when he spoke to God. This seems unlikely because horns were traditionally an attribute of husbands of adulterous wives. Perhaps they were to hold gilded bronze shafts representing the rays of light which shone from his head.

Built 12th century

From the climb up, the church of Quattro Coronati looks like a castle; it now houses an enclosed order of nuns. It was rebuilt and fortified following the Norman Sack of Rome when much of the original fourth- and fifth-century church was destroyed. The first court occupies the site of the atrium of the earlier church, and the second court was once part of the nave, whose columns can be seen inset in the walls. Inside the church itself the proportions appear peculiar because although the Romanesque church was greatly truncated, the huge apse of the first church, now covered with Baroque frescoes, was retained. The tomb of the four unnamed martyrs, who refused to carve pagan statues, is in the crypt. On the left is the entrance to the cloisters, one of the most peaceful spots in Rome; ring the bell to be let in by a nun who will expect a donation. Back in the second courtyard on the left, is a door to the Chapel of St. Sylvester: ring for the key which appears on the wooden turntable in exchange for another donation. Inside the chapel mid thirteenth-century frescoes depict the conversion of Constantine following his cure for leprosy.

Address

Via dei Santi Quattro Coronati, Roma

✆ 73 53 21

Map reference

⑤①

How to get there

To Colosseo: Metro B. Buses 11, 15, 27, 81, 85, 87, 186, 204, 673. Trams 13, 30b

Opening times

Mon to Sat 9.30–12 and 4–6

Entrance fee

Donations required for the cloisters and the Chapel of San Silvestro

SANTA SABINA

Built 422–432, renovated 9th and 13th centuries

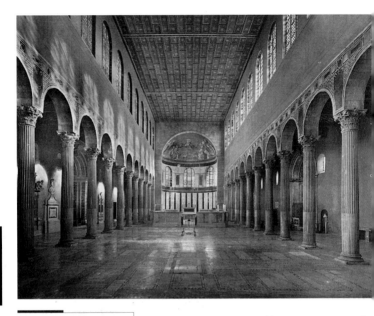

Address
Piazza Pietro d'Illiria, Roma

Map reference
(52)

How to get there
To Via di Santa Sabina:
bus 94. To Circo Massimo:
Metro B

Opening times
Daily 9–12.30 and 3.30–6

From the outside the twelfth-century campanile and fifteenth-century portico cover what is perhaps the most perfect example of an early Christian basilica in Rome. It was built on the site of the house of Saint Sabina, a Roman matron who was converted to Christianity by her Greek slave; both were martyred in the second century AD. In the vestibule are fifth-century cypress-wood doors. Some panels have been lost and they are probably now in the wrong order, but the scene of the Crucifixion in the top left is possibly the oldest in existence. Inside, the church is beautifully proportioned and brilliantly lit by large windows of translucent selenite, carried by a splendid set of fluted Corinthian columns which must have come from an ancient building. Originally, the nave walls and apse were covered with mosaics but the only remains are above the doorway with a dedication in classical gold lettering and figures representing the Church of the Jews and the Church of the Gentiles. The church was given to St. Dominic and in the thirteenth-century cloister are his rooms and those of St. Thomas Aquinas.

Built 463–483, renovated 1450s

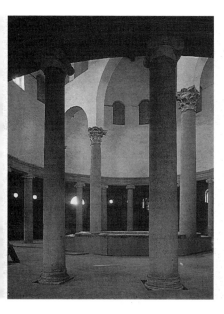

Set back from the road, this church has a delightfully rustic entrance; originally it was set in gardens with cool fountains. For years, the building has been under restoration and opening times are erratic, but the workmen do not seem to mind people coming in. If it appears closed, visitors can try the custodian at no 7. Inside is stupendous. This is one of the oldest churches in Rome, thought to have been built on the site of the round building of Nero's great meat market, and the columns are undoubtedly from antiquity. The traditional circular shape suggests that it may have been built as a mausoleum. Originally there were four arms (the only surviving one now serves as the vestibule) and there were three concentric aisles. The outer one was taken down in the 1450s and the colonnade walled in, greatly reducing the size of the building. This wall was painted with somewhat second-rate frescoes in the 1570s and 1580s by Antonio Tempesta (1555–1630) and others showing gory scenes from the lives of the early Christian martyrs, but little can detract from the magnificence of this space.

Address
Via di San Stefano Rotondo
7, Roma
℗ 7046 37 17

Map reference
㊳

How to get there
To Via Claudia: buses 15,
118, 673

Opening times
Mon to Fri 9–12

Built 1502

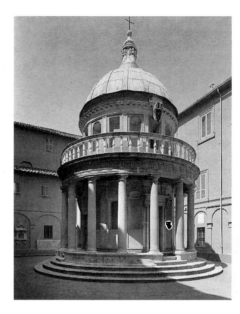

Address
Piazza San Pietro in
Montorio, 2, Roma. (In the
courtyard of San Pietro in
Montorio)
✆ 581 39 40

Map reference
(54)

How to get there
To Passeggiata del
Gianicolo: 41

Opening times
Daily 9–12 and 4–6.30

The Tempietto by Bramante (1444–1514) is a perfect piece of High Renaissance architecture. It was commissioned by Ferdinand and Isabella of Spain to mark the spot where St. Peter was thought to have been crucified. Traditionally a martyrium was round, and inspired by the circular Temple of Vesta in the Forum and other Classical prototypes, Bramante revived the cella and peristyle, adding a flight of steps, a Renaissance drum and a dome of perfect proportions. He used plain materials and the undecorated Doric order appropriate to St. Peter, who was a poor fisherman. The frieze includes carvings of his liturgical items. As a monument, the exterior design was considered more important than the interior, and Bramante had intended to set his temple in a square courtyard with niches in the corners, transformed into a circle by sixteen columns echoing those of the peristyle. The Tempietto has great dignity despite its tiny size, and since Palladio included it in his *Quattro Libri* it has been one of the most influential designs in the history of Western architecture.

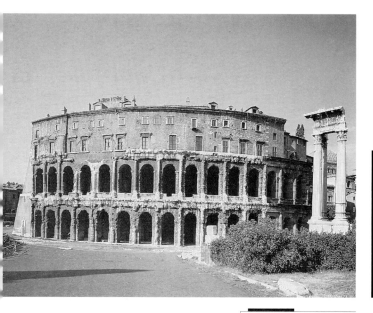

The Theatre of Marcellus stands next to three beautiful columns remaining from the Temple of Apollo (built in 433 BC and restored 33 BC) where celebrations in honour of the god included theatrical spectacles. Earlier and smaller than the Colosseum, it would have seemed vast at the time it was built, seating some 20,000 spectators. It was begun by Julius Caesar and finished by Augustus, who dedicated it to the memory of his nephew and son-in-law who had died in 23 BC. Originally there were probably three storeys with the Doric, Ionic and Corinthian orders, but following the fall of Rome it was plundered, and in the Middle Ages it was turned into a fortress for the warring noble families of Rome. In the sixteenth century it was made into a palace by Baldassare Peruzzi (1481–1537), and the famous Orsini family lived there for some two hundred years. It is now a maze of apartments where many hid during the German occupation of 1943–44.

Address
Via del Teatro di Marcello, Roma
© 481 48 00

Map reference
⑤⑤

How to get there
To Piazza Monte Savello: buses 15, 23, 57, 90, 90b, 94, 95, 116, 160, 204, 713, 716, 774, 780

Built 1732–62

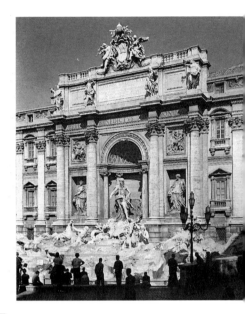

Address
Piazza di Trevi, Roma

Map reference
56

How to get there
To Via del Tritone: buses
52, 53, 56, 58, 58b, 60, 61,
62, 71, 81, 95, 119, 492

Narrow medieval streets lead to a spectacular display of falling water; the great Baroque fountain covers an entire side of the Palazzo Poli and the basin fills most of the tiny piazza. Originally, Alberti designed a simple fountain which was restored by Urban VIII (1623–44) using funds raised by a tax on wine. The present design was constructed under the Corsini Pope, Clement XII, whose coat of arms appears at the top. In the centre, Neptune rides out with wild sea horses and tritons; in the niches are figures of Health on the right and Abundance on the left. Above them are reliefs of the legend of how a young girl led Agrippa's thirsty soldiers to a spring which was subsequently named Aqua Vergine, and which still feeds the Trevi Fountain as well as many other fountains in Rome. On the left is a relief of Agrippa approving plans for the aqueduct and above are statues representing the Four Seasons. A tradition claims that those who drink its waters or throw a coin into the fountain will return to Rome.

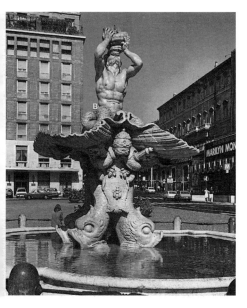

Before Bernini (1598–1680), Rome's many fountains were designed as pieces of geometry using architectural details for decoration. Here, his imagination devised a fountain inspired by Classical myths. Triton was half-man, half-fish, son and escort of Neptune who plays in the waves blowing trumpets. Water spouts high from a conch shell blown by the Triton as he kneels on an open scallop shell supported by four dolphins. In between their tails is the coat of arms of his patron, the Barberini Pope Urban VIII. Another fountain designed by Bernini the following year is at the beginning of the Via Veneto and is known as the Fountain of the Bees from the Barberini device which decorates it. It has an inscription which says that the Pope generously gives the water to the public and their animals. The fountains are difficult to appreciate in an area which was part of massive building projects in the 1880s which destroyed gardens, waterfalls and stupendous views over Rome, allowing for the influx of modern traffic.

Address
Piazza Barberini, Roma

Map reference
(57)

How to get there
To Piazza Barberini: Metro A. Buses 52, 53, 56, 58, 58b, 60, 61, 62, 95, 116, 119, 209, 492

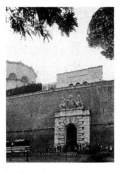

Address
Viale del Vaticano, Roma
℗ 69.88.33.33

Map reference
㊽

How to get there
To Piazza del Risorgimento:
buses 23, 32, 49, 51, 81.
492, 907, 990, 991. Tram:
19. To Ottaviano: Metro A

Opening times
Winter: daily 8.45–1.45;
last ticket 12.45. July to
September and Easter: Mon
to Fri 8.45–4.45; Sat
8.45–1.45. Closed every
other Sun and religious and
public holidays, except the
last Sunday of the month

Entrance fee
L 13,000. Free on last Sun
of the month

A visit to the Vatican Museums requires stamina: it is best to be selective, and the Sistine Chapel and Raphael Stanze are obviously not to be missed. It may be worth arriving at opening time and heading straight for the Sistine Chapel to avoid the crowds. The museum is subdivided into different collections which can be confusing as these are sometimes named after the popes. However, directions to the two highlights are clearly marked. These bypass some of the Vatican's other treasures: the Egyptian and Etruscan rooms and the Greek and Roman sculpture museum, which together form the largest collection of antique art in the world; the Pinacoteca or Art Gallery which houses, in addition to the works described in the following pages, Raphael's tapestries from the Sistine Chapel; *Scenes from the Life of St. Nicholas of Bari* by Fra Angelico; the Library begun by Nicholas V in 1447; the Borgia Apartments; the Chapel of Nicholas V; the Raphael Loggia overlooking Bramante's Cortile di San Domaso and Michelangelo's frescoes in the Pauline Chapel. These last two are often shut.

The Vatican Palace has been the residence of the Popes since 1377, when Gregory XI returned briefly from Avignon to find the Lateran Palace in disrepair. The fifteenth-century Popes restored and added to it, beginning the construction of the Sistine Chapel, but the major extension began under Julius II when Bramante levelled off the ground of the Vatican gardens between the Palace and the Belvedere at the top and joined them with two massive corridors. He intended the two upper levels to contain gardens, fountains and his impressive collection of Classical sculpture; the lowest was to be for theatrical performances, tournaments and other entertainments. His plans are clearly visible but have been ruined by the alterations of subsequent Popes, especially the construction of the Library of Sixtus V in 1585–90 which cut the courtyard in two.

The Stefaneschi Altarpiece

1315

Giotto di Bondone and assistants

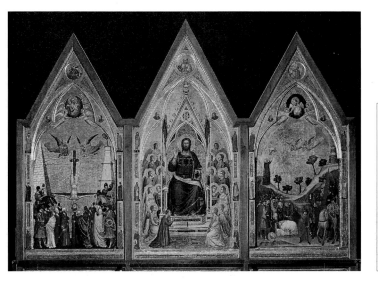

This altarpiece was painted for Cardinal Stefaneschi, who appears twice, traditionally reduced in scale in relation to the sacred figures. On central panel on the front he kneels by Christ's right foot; and on the back, again in the centre, he donates the polyptych to St. Peter. The latter shows how the panels were once enclosed in an elaborate Gothic frame. In the centre, Christ sits enthroned. This type of majestic image was rare for its period, more usual is that of the enthroned Virgin who appears beneath Him, flanked by saints. The narrative panels either side illustrate the martyrdom of the two chief apostles who were executed in Rome. On the left, St. Peter is crucified upsidedown beside the Pyramid of Caius Cestius, situated just outside the city walls. On the right, Paul, who as a Roman citizen was allowed a kinder execution, is beheaded. In the pinnacles of both scenes, the saints are transported by angels to heaven.

Early writers recognized that with Giotto a new style of painting was emerging. Although Christ's throne is Gothic and the angels surrounding him cover the surface of the panel, the figures are given more weight and volume than in previous paintings and a greater sense of naturalism can be seen, especially in the anatomy of the naked St. Peter. Giotto became extraordinarily well-known in his lifetime and worked for many of the richest and most powerful men in Italy, but controversy and speculation surround his work because no documentation exists. The Stefaneschi Altarpiece may have been painted for the Holy Year of 1300, but many believe this date is too early.

Sixtus IV

1477

Melozzo da Forlì

This fresco by Melozzo da Forlì (1438–94) was on the wall of the Vatican Library before it was detached and transferred to canvas in the nineteenth century. It depicts Pope Sixtus IV appointing the Humanist known as Platina as the Vatican's first Librarian in 1475. Sixtus added to and converted Nicholas V's library, sparing no expense. His family device of the oak leaf and acorn, seen in the pilasters of this fresco, appears thoughout the decorative scheme. Like other popes, Sixtus IV secured important and lucrative posts for close family members. The figures standing before the portly Pope are his nephews, Giuliano della Rovere who became Pope Julius II; Giovanni della Rovere who gained the lordship of Senigallia; and Raffaele Riario who was created Cardinal in 1477.

Saint Jerome

c. 1481–82

Leonardo da Vinci

This painting was found in 1820 in a second-hand shop in Rome. It had been used as a door of a small wardrobe with the Saint's head cut out. A few years later the missing part was found in a cobbler's workshop being used as a table-top. Leonardo (1452–1519) shows the penitent Jerome in the desert, where he became a hermit for four years and had only wild beasts for company; a legend claims that he befriended a lion when he plucked a thorn from its paw. The painting has hardly been started; Leonardo worked in monochrome before adding any colour, modelling with light and shade and yet, with the barest outlines, he describes the forms and indicates a rocky landscape at the top left. Leonardo's studies of anatomy are seen in this haggard figure, whose gesture expresses isolation and despair.

c. 1520

Raphael (Raffaello Sanzio)

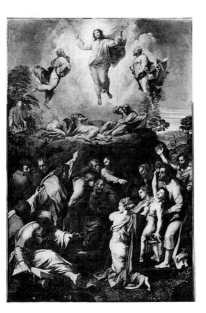

VATICAN MUSEUMS: PINACOTECA

The Transfiguration occurred when Christ went to Mount Tabor with Peter, James and John and His face shone like the sun, His clothes became white as the light, Moses and Elijah appeared and God's voice proclaimed 'This is my Son'. This episode takes place in the upper part of the painting while the lower illustrates a scene where the Disciples, without Christ, are unable to help an epileptic. On His descent from the mountain, Christ cured the boy and blamed His Disciples' failure on their lack of faith. Confusion is expressed by the variety of their gestures, but the whole composition is linked by a large figure of eight.

Raphael's painting was commissioned by Cardinal Giulio de' Medici, later Pope Clement VII, for the Cathedral of St. Just in Narbonne, where he had been nominated Archbishop in 1513. It seems that he had no intention of going there but wanted instead to offer a large altarpiece. At the time, Raphael (1483–1520) was extremely busy and failed to produce the picture so the Cardinal commissioned a rival painter, Sebastiano del Piombo, to paint another, *The Raising of Lazarus*, now in the National Gallery, London. Spurred on by the competition, Raphael was working on the painting when he died in 1520. It was probably finished by his pupils and the weaker figures in the upper half are attributed to them. Sebastiano's painting was sent to Narbonne and Raphael's was kept, which surely indicates the Cardinal's preference.

The Entombment

1602–04

Caravaggio
(Michelangelo Merisi)

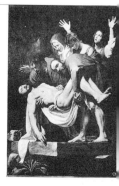

The Entombment by Caravaggio (1571–1610) was painted for the Vittrici Chapel in the church known as the Chiesa Nuova. The Chapel was dedicated to the Pietà, and the horizontal body of Christ in this picture makes direct reference to Michelangelo's famous sculpture (page 90). Set against a dark background, the figures were designed to look as though they were lit from the building's natural light source. The composition moves diagonally, from one of the Marys at the top right who throws up her arms praying for the miracle to come, down through the heads to Christ, whose body is being lowered over the stone jutting out at eye level, into the space in which we stand. The figures are grouped closely together, the elderly Virgin and clumsy Nicodemus contrasting with Christ's idealized form.

The Martyrdom of Saint Erasmus

1628–29

Nicolas Poussin

The Martyrdom of Saint Erasmus by the French painter Poussin (1593/4–1665) is difficult to appreciate today because the subject is so gruesome. Erasmus was an early bishop in Campania who was martyred by having his entrails wound round a winch. Poussin's saint is chained to a rack, lying on his bright red bishop's cope and white mitre while he is disembowelled against a backdrop of cherubs, columns and a statue of Hercules. The Counter-Reformation decreed that it preferred subjects of Christ and the martyred saints in scenes which showed them afflicted, wounded and unsightly. The painting was commissioned by Cardinal Francesco Barberini for the left tribune of St. Peter's, and the Cardinal presumably chose a subject which would accord with the Church authorities for such a public place.

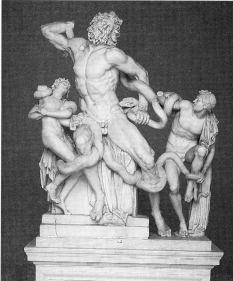

In Greek mythology, Laocoön was the Trojan priest who advised his citizens not to accept the gift of the hollow wooden horse the Greeks had made in order to smuggle their forces into Troy. They had dedicated it to the goddess Athena, whose temple was in the city, and angered by Laocoön's suspicions, Athena sent two huge serpents to kill him and his two sons while he was officiating at the altar. This group was carved in Rome by three sculptors from Rhodes, and shows the bearded Laocoön struggling with a serpent as it bites him on the hip. His younger son has already collapsed, while the elder tries in vain to free himself.

The sculpture was found in 1506 on the Esquiline and as soon as he heard of its discovery, the architect Giuliano da Sangallo rushed down to see it, carrying with his small son on his shoulders and accompanied by Michelangelo. He immediately recognized it as the statue mentioned by Pliny, who had claimed that it was to be preferred above all other works. Julius II then acquired the group, and Pope Clement VII commissioned Giovanni Angelo da Montorsoli to restore it in 1532, when he recreated the arms. Laocoön's original arm was found in a marble cutter's shop in 1905, and Montorsoli's mistakes can be seen in the plaster-cast which stands near the original. The Laocoön had a great effect on Michelangelo, and the movement, violent naturalism and contortions of the figures as they are crushed to death has been a source of inspiration for many painters and sculptors since the Renaissance, as the work has become famous through numerous casts and engravings.

The Belvedere Torso

First century AD

Apollonios

This powerful fragment of a muscular figure was part of Pope Julius II's collection of Classical sculpture in early sixteenth century. Although it is headless and limbless it has tremendous vitality, which is especially evident when it is compared with the other statues in the same room. Sitting on the skin of some wild animal, the figure is thought to be Hercules, but he could be any hero from Greek mythology. On the rock on which he rests is clearly carved 'Apollonios, son of Nestor, of Athens, made it' and this sculptor lived in Rome at the end of the Republic.

The Belvedere torso may have been attached to a pediment but, nevertheless, it is a fully three-dimensional work; as the figure twists, his body demands to be seen from every angle. It was admired by many artists but especially by Michelangelo, and of all the antique sculpture he knew, this was the most influential. While the Laocoön and Apollo Belvedere had their missing limbs reconstructed in the 1530s, this work was left alone, but Michelangelo's twenty *Ignudi* on the Sistine Ceiling can be seen as a variety of restorations of this famous piece. Michelangelo studied it constantly and remarked: 'This is the work of a man who knew more than nature'.

The Apollo Belvedere is thought to be a Roman copy in marble of a Greek bronze from the fourth century BC; the lost original once stood in the market place in Athens. The young god appears to have just shot an arrow and is watching its flight. The statue represents an ideal form of physical beauty. With his head turned and weight on one foot as he walks forward, all movement is controlled and his form is nature perfected. The Neoclassicists saw it as the highest achievement in art.

The Classical collection in the Vatican was founded by Pope Julius II, who in 1503 brought his prize pieces from his palace near San Pietro in Vincoli. He housed them in the Belvedere, a summer house which had been built some twenty years earlier in the grounds of the Vatican, which gave this Apollo and the Belvedere Torso their names. The earliest known mention of the Apollo dates from 1491 when it was noted that both hands were missing, and in 1532 Pope Clement VII asked Giovanni Angelo da Montorsoli to reconstuct the statue. Unfortunately, he sawed off and threw away much of what was left of the right arm and enlarged the tree-stump as support. Early this century this was removed but metal rods were placed behind to stop the statue keeling over, causing further damage to the marble.

The Chapel of Nicholas V

1448–50

Fra Angelico

The little Chapel of Nicholas V is one of the few tranquil places in the Vatican. It can easily be missed as the entrance is tiny, and is situated just off the Room of the Chiaroscuri, called after the monochrome frescoes on the walls. Nicholas V converted what was probably an early thirteenth-century military tower into his private chapel and he commissioned Fra Angelico (1387–1455), a Dominican painter monk from Florence, to do the frescoes.

On the blue vault of the ceiling are the Four Evangelists, and on the pilasters, the Doctors of the Church. Separating the scenes of the fresco cycle are decorative garlands and heads of putti, and on the floor are the signs of the Zodiac and the name of the Pope. The original altarpiece by Fra Angelico is now lost. The cycle depicts the two deacon saints, Stephen in the upper section and Lawrence in the lower. St. Stephen, the first martyr, is seen being ordained by St. Peter, distributing alms, preaching, disputing among the Elders and being lead to martyrdom when he was stoned to death. St. Lawrence, too, is shown being ordained, receiving and distributing alms, before the tribunal of the Emperor and martyrdom, and being burnt on a gridiron. The narratives are set into contemporary architecture and the whole is pervaded by soft pinks and blues with sparkles of gold. Fra Angelico's pictures have a quiet modesty; he painted only religious subjects and he apparently never took up his brush without first making a prayer.

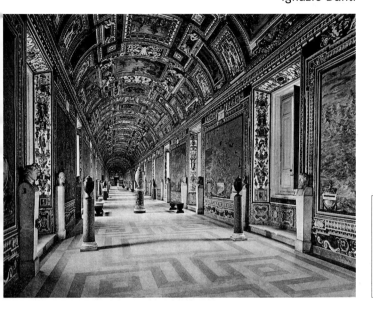

The Gallery of Maps was painted by Ignazio Danti of Perugia, a Dominican cosmographer, architect and painter. The maps show both ancient and modern Italy, her various regions and islands off the mainland, the papal territory of Avignon and several towns and seaports. Perhaps the most interesting is the map of Venice on the end wall as so little has changed since the time it was painted. The ceiling is decorated with stuccoes and frescoes by a group of painters supervised by Girolamo Muziano, and along the wall are busts of Socrates, Plato and other sages.

The Gallery is one of the corridors of Julius II's vast extension of the palace begun in 1505, and from one side are views of the Cortile Belvedere where the Pope planned to hold entertainments, while from the other are good views of the Vatican Gardens.

The decorations were commissioned by Pope Gregory XIII, a militant supporter of the Counter-Reformation. He secured the German College and established English, Greek and Hungarian seminaries in Rome. He also attempted to halt Protestantism by encouraging the invasion of England by Spain and Ireland, and when the latter failed he supported a plot to assassinate Queen Elizabeth I. In 1582 he reorganized the calendar by dropping ten days and making rules for leap years; this was accepted by Catholic states but was not followed by Protestant countries for over a century. The Pope completed the Gesù (page 45) and supported the Jesuits' missionary work as far off as China, Japan and Brazil. Although he was interested in Europe and the New World, perhaps he preferred to see only states loyal to the Papacy.

✪ The Sistine Chapel

Built 1473–81, decorated 1481–1541

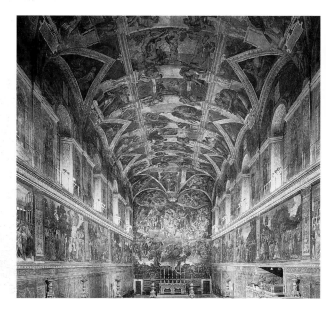

The Sistine Chapel was built by Sixtus IV, from whom it takes its name, as the private chapel of the popes and for the conclaves which elected them. Before Michelangelo's stupendous ceiling frescoes, the vault was painted blue with gold stars and the Pope commissioned some of the most renowned artists in Italy – Botticelli (*c.* 1445–1510), Ghirlandaio (1449–94), Perugino (*c.* 1445–1523), Signorelli (1470–1523) and Rosselli (1439–1507) to fresco the walls. These depict scenes from the life of Moses on one wall and from the life of Christ on the other. The inscriptions above them explain that they represent Moses as the written law and Christ as the law of the new dispensation, which is entirely appropriate for the chapel where God appoints his Vicar on Earth.

The frescoes Michelangelo (1475–1564) painted on the ceiling are some of the most potent images of Western art. The ceiling is massive and from the cornice the artist constructed a wooden bridge where he endured stifling heat in summer and had to paint standing with his head almost at right angles to his body. He divided the shallow vault with a trompe l'oeil architectural framework in which he placed the prophets and sibyls of the Old Testament and, down the central strip, nine scenes from Genesis. The Drunkenness of Noah is directly above the entrance and the frescoes read chronologically backwards until only God appears above the altar. Having entered as a sinner, passing under the Fall of Man, the soul is purified as it approaches God.

More than twenty years after painting the ceiling, Michelangelo was commissioned by Paul III to fresco the *Last Judgement* on the altar wall.

Aaron's right to high-priesthood was contested by Korah. His brother Moses then asked all the opponents to come with incense as an offering to God, a rite reserved only for priests. As they came 'the earth opened her mouth, and swallowed them up, and their houses and all the men that appertained unto Korah, and all their goods'. For recognition, Moses appears throughout the scheme in golden yellow and green, often with shafts of light rising from his head, and he frequently appears several times in each fresco in order to participate in many scenes of the narrative. Here, he is on the right with the rebels gathering round him in threatening mood; at the altar brandishing his rod sending incense flying; and again on the left witnessing the fall of Korah and his associates. The subject, like the others, was chosen to emphasize the primacy of the Papacy, and in particular here to warn those who would revolt against Papal authority.

Botticelli (*c.* 1445–1510) and the other artists who painted the frescoes on the walls must have worked out a scheme so that the compositions worked together in harmony. This meant subordinating individual styles to the overall effect as it is only in details that each artist can be identified. The principal action takes place in the foreground, rocks or monuments are placed firmly in the middle, and the middle distance is defined symmetrically right and left and in most, the horizon is visible. The monument is a replica of the Arch of Constantine (page 19).

God Creating the Sun, Moon and Planets

1508–12

Michelangelo Buonarroti

God Creating the Sun, Moon and Planets is perhaps the most dynamic fresco on the ceiling, and reflects the energy of both Michelangelo (1475–1564) and Pope Julius II who commissioned it. The artist began painting the ceiling above the entrance to the chapel, and having completed a third of the area in 1511, he took down the scaffolding and realized that some of the figures, notably in *The Flood*, were too small to be seen from the ground. He consequently enlarged the figures to the maximum within each framework, and as he progressed towards the altar his figures become increasingly confident.

Julius II originally asked Michelangelo to decorate the vault with the Apostles and the usual ornament, but the artist decided that the result would be 'a poor thing', so the Pope allowed him to paint what he wanted. Much has been written on the choice of subjects from the opening of Genesis, but this programme not only accords with the theological requirements of the Chapel but also gave Michelangelo the challenge of visualizing dramatic narratives. Here God is more like an image of Zeus than the traditional solemn, static Father. On the right with a furious gesture he creates the universe and on the left he flies off with no time to spare. Seen from below, this is a somewhat audacious image of the Almighty; His body is described beneath the drapery and the soles of His feet are showing.

The Hebrew Prophets and pagan Sibyls who predicted the coming of a Messiah fill the vaults of the ceiling, sitting above the ancestors of Christ in the lunettes. They are identified only by the names inscribed beneath their thrones, except for Jonah who is shown with his attribute, the whale. As he was three days in the belly of the whale just as Christ was three days in Hell, he is placed above the altar as a prefiguration of the Resurrection. Michelangelo's Prophets and Sibyls are enormous but each is individual and expresses the dignity of their place in history. In spite of her muscular arms opening or closing the massive book, the Libyan Sibyl has extraordinary elegance and grace; her feet are carefully poised as she turns her head to look down at Christ's ancestors. The yellow and lilac of her robes are a bold combination and the recent restoration of the ceiling removed layers of dirt to reveal Michelangelo's striking colour scheme.

When Michelangelo (1475–1564) was commissioned to fresco the ceiling he had to temporarily halt a monumental project on which he had been working for the previous three years. This was to be the tomb of Julius II, and not surprisingly, many of the ideas he had for the tomb were transferred to the fresco, especially the architectural divisions of the ceiling and the *ignudi*, or nude figures framing the panels. With the ceiling completed, he returned to the project of the tomb and carved *Moses*, now in San Pietro in Vincoli (page 92), as a three-dimensional variant of the Prophets.

The Last Judgement

1535–41

Michelangelo Buonarroti

When Michelangelo (1475–1564) returned to the Sistine Chapel some twenty years after he had painted the ceiling, a different climate prevailed. The Sack of Rome in 1527 had left Rome sorely wounded. Lutheran followers were growing and the Protestant movement was taking hold; in 1534 Henry VIII of England defected from the Catholic Church. The Last Judgement is full of pessimism and doubt. This subject is traditionally found at an entrance, and the decision to place it behind the altar would have emphasized the theme of eternal damnation as a warning to those who questioned the supremacy of the Pope.

Restoration has removed the grime of candle smoke, and the over-painting due to later objections to nudity. Christ storms out with a compassionate expression but a condemning gesture. Beside him the Virgin recoils and either side are St. Peter with the keys and Adam, both with anxious faces. Below Christ are St. Lawrence with his gridiron and St. Bartholomew, who holds the knife with which he was flayed and his empty skin in which Michelangelo has placed a self-portrait. At this level there are other saints and martyrs with their attributes; St. Andrew with his cross, St. Sebastian with the arrows, and St. Catherine and her wheel. Above, in the lunettes, figures struggle to support the instruments of Christ's Passion. In the lower half, angels blow trumpets to wake up the dead; those elected throw off their shrouds, but the damned sink in despair to be met by Minos, who winds his snake-like tail around his body to indicate the number of the sinner's circle of torment. Charon is ready with his boat to drive the damned to the Kingdom of Satan.

These rooms were reconstructed and frescoed by Pinturicchio (1454–1513), the most fashionable painter in Rome, for the Borgia Pope, Alexander VI. Five of the six rooms retain the late fifteenth-century decoration after which they are named. There is the Room of the Sibyls – each with a prophet to whom they foretold the coming of a Messiah – with astrological scenes in the spandrels; the Room of the Creed – written on scrolls held up by the Apostles and Prophets; the Room of the Liberal Arts – grammar, rhetoric, logic, arithmetic, music, astronomy and geometry written on their stately thrones; the Room of the Saints – Catherine of Alexandria, the hermits Paul and Anthony Abbot, Sebastian, Susanna and the Elders and Barbara; and the Room of the Mysteries of the Faith, showing The Annunciation, Nativity, Adoration of the Magi, Resurrection, Ascension, Pentecost and the Assumption of the Virgin.

It is unlikely that many Borgia portraits are included in these frescoes, but Alexander VI appears kneeling before the Resurrection and the Borgia bull and other emblems appear in profusion. The name Borgia is synonymous with vice and corruption but history has probably exaggerated and distorted the family's crimes in an age when cruelty was not unusual. As Spaniards, they were treated as foreigners and were accused of murder, incest and intrigue. In the Room of the Sibyls, the Pope's son, Cesare, had his cousin, Alfonso of Aragon, murdered before he was himself imprisoned by Julius II. The hidden treasure of Alexander VII was found in the Room of the Liberal Arts.

✪ Ceiling of the Stanzá della Segnatura

1508

Raphael
(Raffaello Sanzio)

The four rooms known as the Stanze were the private apartments of Pope Julius II; he moved here from the Borgia apartments when he could stand their villainous associations no longer. From here he also had a good view of the construction of his new Belvedere court. When Raphael (1483–1520) arrived in Rome his talents were immediately recognized and in 1508 Julius employed him to fresco the rooms.

The Stanza della Segnatura is so called because decrees were signed there, but the room was probably the Pope's library; the bookshelves, which were below the frescoes, were later removed. The roundels on the ceiling contain personifications of Theology, Justice, Philosophy and Poetry and the frescoes below relate to these subjects.

The School of Athens

1508–11

Raphael
(Raffaello Sanzio)

The School of Athens in the Stanza della Segnatura is a paragon of High Renaissance painting. Raphael (1483–1520) has gathered together all the great philophers of antiquity and animated them in debate. In the centre, Plato speculatively points to the sky as he argues with Aristotle who reasons for evidence; Socrates, in green on the left, logically counts off points on his fingers. In the foreground the mathematician Pythagorus stands on the left, and on the right the astronomers Zoroaster and Ptolemy holding globes stand behind the geometrician, Euclid. They are presided over by trompe l'oeil statues of Minerva and Apollo. The scene is set in a monumental building not unlike Bramante's new St. Peter's. Raphael has given some contemporary likenesses: Plato resembles Leonardo, Euclid looks like Bramante and Raphael's self-portrait is second from the right.

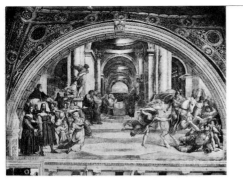

The Expulsion of Heliodorus

1512–14

Raphael
(Raffaello Sanzio)

The Stanza di Eliodoro is frescoed with scenes of God's miraculous interventions on behalf of the Church: an angel frees St. Peter from prison, a host spurts blood onto the corporal at Bolsena when a German doubts the Eucharist and St. Peter and St. Paul halt Attila the Hun's march on Rome just outside her city gates. *The Expulsion of Heliodorus* comes from the Apocrypha. The court official Heliodorus was sent to collect money kept in trust for widows and orphans in the Temple of Solomon, but the High priest prayed for help and a horse and rider appeared and drove him out. In his litter on the left, Julius II witnesses the scene and looks very like the priest who is able to call for God when in need.

In 1512 the Sistine Ceiling was finished and Raphael (1483–1520) quickly adopted Michelangelo's more dynamic forms in his own work.

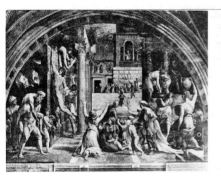

Fire in the Borgo

1517

Raphael
(Raffaello Sanzio)

Julius II died in 1513 but the decoration of the Pope's private apartments was continued by his successor, Leo X. This room has scenes from the lives of Leo III and Leo IV; they have Leo X's features and make obvious references to the later Pope's achievements. The fresco of the *Fire in the Borgo*, which gives the Sala dell'Incendio its name, depicts the fire that broke out in the area of the Vatican in 847. When Leo IV appeared on the loggia of St. Peter's and made a sign of the Cross, it miraculously stopped. In this way Leo X alludes to himself as a founder of modern Rome. The composition is like a stage set, with theatrical figures and architectural backdrops; the facade in the background is that of old St. Peter's. On the left is the fire, and the figures in the foreground are Aeneas carrying his father Anchises on his back, while leading his son out of burning Troy.

THE VICTOR EMMANUEL MONUMENT

Built 1885–1911

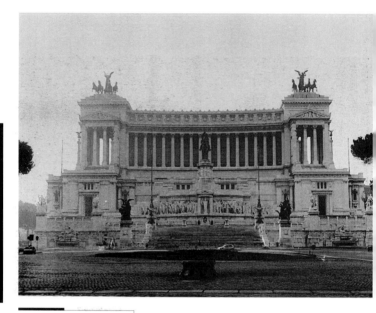

Address
Piazza Venezia, Roma

Map reference
(59)

How to get there
To the Piazza Venezia:
buses 44, 46, 56, 57, 60,
62, 64, 65, 70, 75, 81, 85,
87, 90, 90b, 95, 160, 170,
181, 204, 186, 492, 710, 718,
719

The massive monument to Victor Emmanuel which dominates the Piazza Venezia was erected to celebrate the Unification of Italy in 1870 and her first king. It stands eighty metres high and dwarfs not only the buildings around it but also the Capitoline Hill behind. Like the Eiffel Tower in Paris, it cannot be ignored and arouses contradictory emotions. A large area of medieval and Renaissance Rome was demolished to make way for the monument, which gleams in brilliant white Brescian marble, standing out from the soft ochres of other buildings in the city. An international competition to design the monument was held and Giuseppe Sacconi's plan was chosen out of ninety-eight entries. His Hollywood reconstruction of the Imperial Palace was nicknamed 'the wedding cake' by English soldiers during World War Two. At the top of the steps lies the Italian Unknown Soldier from World War One, and inside is a police station and the archives of the Institute of History of the Italian Risorgimento, as well as water tanks to feed the fountains.

Gardens laid out mid-16th century

Tivoli is on the slopes of the Sabine Hills overlooking the Campagna, about thirty kilometres from the centre of Rome. By the first century BC it had become a holiday resort for wealthy Romans, but now it is most famous for the stupendous fountains of the Villa d'Este. Originally a monastery, in 1550 the Villa was given to the Governor of Tivoli, Cardinal Ippolito d'Este, and for twenty-two years he refashioned the building and laid out the gardens according to the designs of Pirro Ligorio (c.1500–83). The monastery was converted into a summer palace, with grand flights of stairs, loggias with magnificent views and rooms decorated with frescoes and stucco work. The gardens were intended to illustrate the story of Hercules and the Garden of Hesperides. To supply them with water, aqueducts were built from the river and mountains nearby and had to be cut under part of the city. Amongst the numerous fountains is one which originally played a water organ, and the so-called Alley of a Hundred Fountains, above which a series of boats and lilies spout water. At one end of the alley is the Fountain of Tivoli, where a walkway runs behind a waterfall.

Address
Piazza Trento, Tivoli
✆ 0774/22 070

Map reference
60

How to get there
Mainline train to Tivoli
(Roma–Avezzano line) or
COTRAL bus from Rebibbia

Opening times
Mon to Sun 9–1 hour before
sunset. Closed on certain
public holidays

Entrance fee
L 8,000

119

⭐ VILLA FARNESINA

Built 1508–11

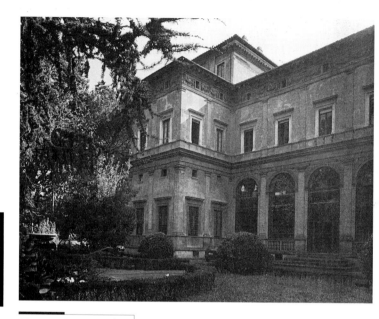

Address
Via della Lungara 230,
Roma
℄ 68 80 17 67

Map reference
�61

How to get there
To Lungotevere Farnesina:
buses 23, 65, 280

Opening times
Mon to Sat 9–1

Entrance fee
Free entry

The Villa Farnesina was built for Agostino Chigi but was later bought by the Farnese, hence its name. Chigi was the papal banker and a great patron of the arts and of printing. He built his villa not as a permanent residence but as a place of entertainment and the loggias and gardens were an important part of the plan. These were laid out with avenues of trees, a great variety of flowers, marble seats and fountains and Chigi's collection of Classical sculpture. Here he held musical and theatrical performances, Classical poetry readings, and astrological and philosophical discussions, and entertained lavishly.

The exterior of the villa is fairly plain, with Doric pilasters and only a decorative frieze of garlands and putti, but Chigi intended to have the outside frescoed. Inside there are frescoes by Raphael, Sodoma, Sebastiano del Piombo and Peruzzi who, bar Michelangelo, were the most renowned artists of the day. The Villa contains the highest concentration of High Renaissance art outside the Vatican.

1517

Raphael
(Raffaello Sanzio)

Now glazed in, this used to be the entrance to the villa. Above is the realm of the Gods: trompe l'oeil tapesteries hang against an open sky and nudes are framed by garlands of fruit. Chigi brought his beautiful mistress, Imperia, to the villa and as she entered it would have appeared that Venus was pointing to her and whispering to Cupid. Her gesture brilliantly flatters any woman arriving at the building because it relates to the start of the story of Psyche and Cupid, when Venus spotted the mortal Psyche and was so jealous of her beauty that she commanded Cupid to make her fall for an idiot. Cupid himself fell in love with Psyche, who was set a series of almost impossible tasks by Venus. Jupiter finally took pity on Psyche and eventually Mercury united her with Cupid.

VILLA FARNESINA

Galatea

1511

Raphael
(Raffaello Sanzio)

The sea-nymph Galatea was loved by Polyphemus, a one-eyed giant or Cyclops. She escaped his attentions and Raphael (1483–1520) shows her being drawn away on her cockle-shell chariot fitted with paddles and pulled by dolphins, while cupids fly through the air and tritons and nereids play in the waves. Raphael's Galatea is an ideal Renaissance beauty; her movement is free and graceful as she turns back to take a last look at Polyphemus. The clumsy giant, sitting on the rock overlooking the sea holding his silent pipes, is by Sebastiano del Piombo (c. 1485–1547) and the landscapes to Galatea's right are seventeenth-century. The ceiling, painted by the architect Peruzzi, shows the position of the planets at 7 pm, on 1 December 1466, the moment of Agostino Chigi's birth.

VILLA FARNESINA

The Room of Perspectives

1517–18

Baldassare Peruzzi

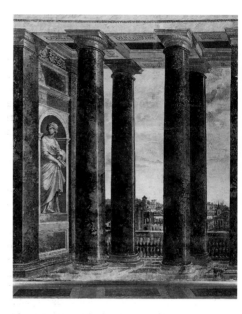

The Room of Perspectives was painted by the architect of the villa, Peruzzi (1481–1536), and was the main living room. It is an early example of Renaissance trompe l'oeil, where the painted porphyry columns of an illusionistic loggia open onto views of Trastevere and the Borgo as it was at the beginning of the sixteenth century; certain buildings can still be recognized. Peruzzi applied a one point perspective, so the real marble floor and its painted counterpart line up from a point between the two doors on the window side of the room. In the nineteenth century it was overpainted with dark reddish brown but this was removed in recent restorations to reveal the original delicate colours: some graffiti were also found, one example, between the columns on the far wall, is from the Sack of Rome in 1527. Vulcan is at his forge above the fireplace and on the frieze are frescoes of mythological scenes.

Next to this room is Agostino Chigi's bedroom, where he had a gold and ivory bed inlaid with precious stones. The frescoes of about 1509 depict scenes from the life of Alexander the Great and are by Sodoma (1477–1549); Alexander is seen before the family of the defeated Darius above the fireplace and to the left, he marries Roxana in a nuptial scene which was considered rather shocking even though Sodoma reconstructed a Classical painting described by Lucan. The rather ridiculous scene of Alexander on his white horse Bucephalus cannot be by Sodoma and was perhaps painted here when Chigi's sumptuous bed was removed.

The Villa Giulia was built for Pope Julius III, who would sail up the Tiber from the Vatican in a boat decked with flowers to spend the day in the company of cardinals, dignitaries and friends. The villa was designed by the architect Vignola (1507–73), the painter and biographer Vasari (1511–74) and the sculptor Ammannati (1511–92). From the outside it looks solid, but the architecture is really just a screen for three courtyards. In the middle, curved stairs lead down to a sunken courtyard, or nympheum, where the caryatids were originally surrounded by ten putti spouting water from the niches. Between the curved stairs a secret grotto was a cool resting place in summer and a hidden spiral staircase led to the upper loggia and gardens beyond. The villa was highly decorated with frescoes; there were also stucco reliefs and numerous antique statues, now lost, damaged or removed. After the Pope's death, 160 boat loads of statues were taken from the villa to the Vatican.

Since 1889, the Villa has housed a magnificent collection of Pre-Roman art, mostly Etruscan from the eighth century BC. The exhibits are the rich spoils from archaeological digs found largely from tombs north of Rome. They are arranged according to where they were found, with maps, explanatory notes or photographs of the sites. There are fascinating cooking implements, glass scent bottles, mirrors, combs and other cosmetic items, candelabra and cauldrons. There are numerous beautiful Greek vases, and the finds from Praeneste reveal astounding technical knowledge, especially in the small gold plaque in filigree decorated with animals from the middle of the seventh century BC. Above all, be sure to see the Apollo and other statues from Veio and the *Bride and Bridegroom Sarcophagus* (page 124).

Address
Piazzale di Villa Giulia 9, Roma
℗ 32.01.951

Map reference
⓺⓸

How to get there
To Viale delle Belle Arti: bus 926; tram 19. To Piazza della Marina: buses 90, 90b, 120, 204, 225, 495, 926

Opening times
Tue to Sat 9–2, Wed 9–7. Sun and holidays 9–1. Closed Mon

Entrance fee
L 8,000

VILLA GIULIA: MUSEO NAZIONALE ETRUSCO

Bride and Bridegroom Sarcophagus
6th century BC

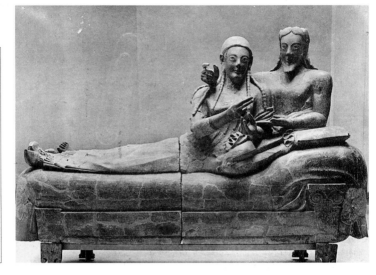

This beautiful sarcophagus was one of the great finds from the necropolis at Cerveteri, which was the most important Etruscan town from seventh to the fourth century BC. It was situated near the sea just north of Rome and its prosperity is reflected in extraordinary workings in ivory, gold, silver and other metals as well as terracotta. The Etruscans believed in a life after death not unlike their own and their tombs, like those of the Egyptians, were laid out with valuable posessions and everyday objects ready for the afterlife. Above the tombs, ceremonies in honour of the dead were performed, including sporting competitions and a funerary banquet. This was an important event: a fresco in a tomb at Orvieto shows the careful preparation of the food where the cook and his assistant are working to the sound of music. Men and women reclined together on couches, a custom highly disapproved of later by the Romans who kept women in a subservient role. Traditionally, the ashes of the dead were put in caskets which often had an effigy reclining on the lid. This double sarcophagus is much larger than usual and we know neither the names of the dead nor why they died so young. They appear to be attending their own funeral banquet and their lively expressions and animated gestures make them look as though they are conversing. Their forms interlock with ease as the man gently rests his arm on the woman's shoulder and the beautiful curves of their bodies echo each other suggesting marital harmony.

ACKNOWLEDGEMENTS

The author and publisher would like to thank the following museums and galleries, individuals and photographic archives for their kind permission to use the following illustrations:

Scala: 6, 8ar, 9, 10, 11, 15a, 29, 71, 76, 97, 101, 105, 110, 122

Angelo Hornak: 8al, 22

The Bridgeman Art Library: 8b (Christie's, London), 13a (Musée des Beaux-Arts, Nantes), 13b (Agnew & Sons, London), 14bl (Private Collection) 15b (Christie's, London), 46 (photo. John Bethell), 112 (Vatican Museums & Galleries, Rome), 113 (Vatican Museums & Galleries, Rome), 114 (Vatican Museums & Galleries, Rome)

National Gallery, London: 12l

A.F. Kersting: 12r, 14r 19, 21, 23, 26, 28, 32, 33, 34l, 34r, 35, 49, 51, 57, 60, 62, 63, 72, 78, 79, 80, 88, 89, 90, 95, 96, 98, 99, 123

The National Trust for Scotland, Fyvie Castle: 16

Fratelli Alinari: 18, 24, 25b, 27, 37a&b, 38a&b, 39&b, 40a&b, 41, 42, 43a&b, 44, 48, 50, 53, 54, 64, 65, 66, 67, 73, 82, 83a&b, 87, 92, 94, 102a&b, 103, 104a&b, 106, 107, 108, 109, 111, 115, 116a&b, 117a&b, 121a&b, 124

Nicholas Ross: 20, 30, 31, 36, 45, 47, 52, 55, 58, 59, 68, 70, 77, 85, 86, 91, 93, 100, 120

Clare MacDonnell: 25a

Sarah Carr-Gomm: 56, 61, 69, 84, 118

Weidenfeld & Nicolson Archive: 74 (photo. Roloff Beny © National Archives of Canada, Ottawa 1986-009)

Tom Parsons: 75, 81

John Lee: 119

The author would like to thank Caroline Bugler, Julia Brown and all Studio Editions, A and J Carr-Gomm, Anna Gendel, Tom Parsons, Nicholas Ross, Clare MacDonnell, the Pacilli and Ernesto and Charles Fellowes, to whom this book is dedicated.

ACKNOWLEDGEMENTS

INDEX

Index of Artists, Sculptors and Architects
Figures in bold refer to main entries

INDEX

A note on the itineraries

The following itineraries have been designed for those with a week to spend in Rome. The city is a fascinating place to explore and it is easy to get side-tracked; it is impossible to see all of Rome in such a short time and visitors may want to select from the suggestions listed below rather than attempt to cover everything. Those with limited time should focus on the starred items. Obviously, time in the city should be organized according to personal interest. For Classical enthusiasts, for example, a day trip to Ostia ⑳ (p. 50) or Hadrian's Villa ⑯ (p. 46) might take preference over Baroque churches, while for garden lovers the cool fountains of the ✪ Villa d'Este at Tivoli ⑥⓪ (p. 119) would make an attractive excursion, particularly at the height of summer. These day trips have not been included in the week's itineraries because of the time involved in travelling out of the city centre. Nor has the Palazzo Farnese ㉓ (p. 55) been listed as an appointment is required to see the interior. ✪ Sant'Ivo alla Sapienza ㉟ (p. 74) is only open for services on Sunday mornings, and so has not been included on the itineraries. Some places, including Santa Maria della Pace ㊹ (p. 80), the Museo delle Terme ⑲ (p. 49) and Forum of Trajan ⑫ (p. 35), have been excluded as they have frequently been found to be closed despite their advertised opening times.

The opening times of the museums, monuments and churches of Rome can be haphazard, and it is always worth endeavouring to double check that the place you wish to see is open before you set off. Restoration work is constantly taking place which can mean that areas are shut off or obscured by scaffolding. As a general rule, most museums are shut for the day by 1.00 p.m. and churches close for a long lunch and siesta before reopening in the late afternoon. As Rome is large, the following itineraries are organized according to area and, where possible, thematically. For example, the first morning concentrates on Classical sites; day two is devoted to Papal patronage at the Vatican; the first option of the fourth afternoon looks at the medieval city and the fifth morning at the Baroque. The entrance fees are correct at the time of publication although, like the opening times, they may well be liable to change. The numbers in circles beside each location are map references.

DAY 1 MORNING

THE VICTOR EMMANUEL MONUMENT ㊾ (p.118)

✪ FORUM ROMANUM ⑩ (p.29)

Temple of Vesta (p.30)
Basilica of Constantine (p.31)
Arch of Titus (p.32)
Arch of Septimius Severus (p.33)

THE PALATINE ㉑ (p.51)

CIRCUS MAXIMUS ⑧ (p.27)

✪ THE COLOSSEUM ⑨ (p.28)

THE ARCH OF CONSTANTINE ② (p.19)

DAY 1 AFTERNOON

✪ THE TREVI FOUNTAIN ㊻ (p.98)

✪ THE PANTHEON ㉖ (p.58)

✪ PIAZZA NAVONA ㉘ (p.60)

The Fountain of the Four Rivers (p.61)

SANT'AGNESE IN AGONE ㉚ (p.63)